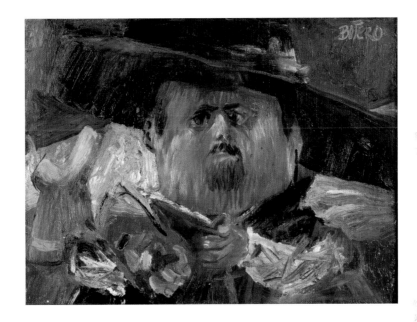

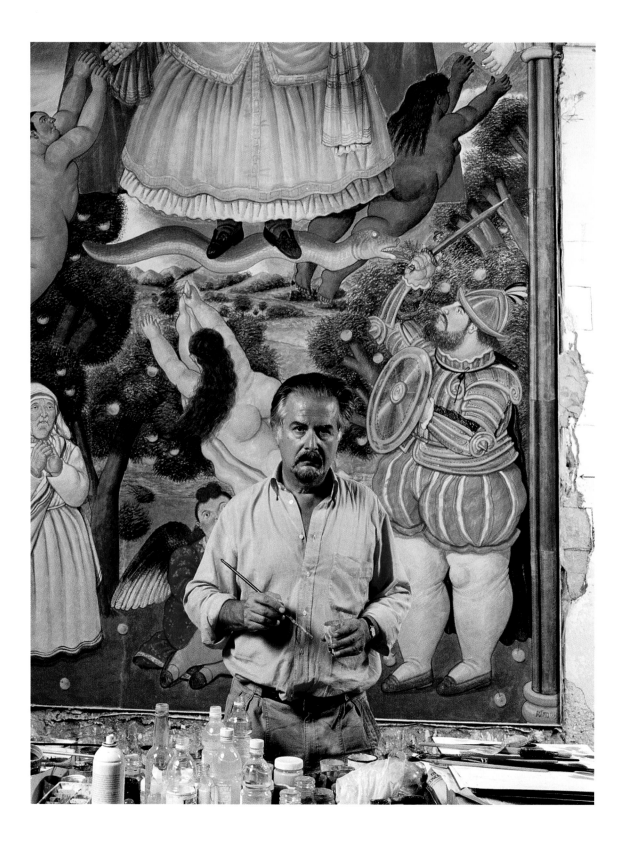

Mariana Hanstein

FERNANDO BOTERO

TASCHEN

KÖLN LONDON LOS ANGELES MADRID PARIS TOKYO

FRONTCOVER:
Loving Couple, 1973
Oil on canvas, 183 x 190 cm
Private collection

BACKCOVER:
Botero in his studio in Tuscany
Photo: Francesco Zizola

PAGE 1:
Self-Portrait, 1959/60
Oil on canvas, 75 x 100 cm

PAGE 2:
Botero standing in front of his fresco **Gate of Heaven**, 1983

Editor: Petra Lamers-Schütze, Cologne
Translation: Michael Scuffil, Leverkusen
Layout and editorial coordination: Gimlet & Partner, Cologne
Cover design: Angelika Taschen, Cologne
Production: Stefan Klatte, Cologne

Printed in Germany
ISBN 3–8228–2129–2

Contents

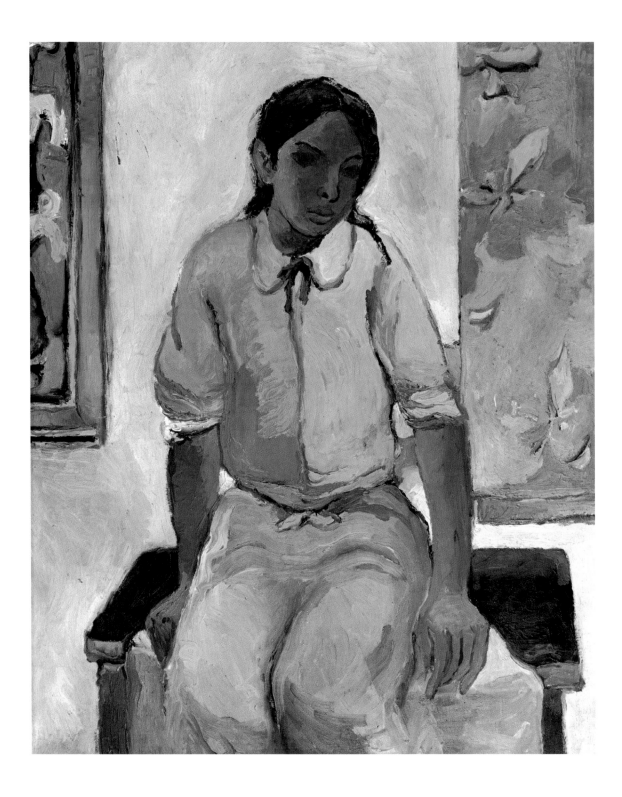

The Beginnings in Colombia
Medellín and Bogotá

In June 1951 an enterprising photographer displayed 25 works in his studio in Bogotá including watercolors, drawings and oil paintings by a young, unknown artist, who had only recently arrived in the capital from the provinces. His success on this occasion was modest, but not discouraging. Not quite one year later, Leo Matiz – for that was the photographer's name – held another exhibition of the same artist's work. This time with resounding success, for all the works were sold. Not one of those involved at the time, neither the amateur art dealer nor the artist nor the buyers, could have had any idea that the 19-year-old Fernando Botero from Medellín would one day be Latin America's most famous painter.

At the time, though, there was nothing to indicate any such development. His pictures were so heterogeneous that visitors thought at first that it was a group exhibition. The gamut of influences evinced by those first pictures ranged from Paul Gauguin to the Mexican artists Diego Rivera and José Clemente Orozco. But the young autodidact from the city in the Andes had never seen original works by these or any other artists. His knowledge of painting derived entirely from books and reproductions. His father, like most South Americans an enthusiast for the French Revolution, owned books with portraits of Madame de Pompadour, Louis XVI and Marie Antoinette. Dante's *Divine Comedy* illustrated by Gustave Doré also had a place in the bookshelves of the young artist's late father. It was here too that little Fernando saw his first nudes. Quite different were the pictures that adorned his school exercise-books – Raphael's *Sistine Madonna*, for example, or Titian's *Assunta*, altogether magical Madonnas, not remotely comparable to the "vírgenes" in the churches of Medellín. And finally there was the hall of a friend's house, where the young man never failed to be impressed by a reproduction of Picasso's *Woman in Front of a Mirror* and another of a picture by Giorgio de Chirico.

"Modern Art" existed in Medellín only in the consciousness of a few intellectuals, with whom Botero came into surprisingly early contact, while still at school in fact. This small elite circle would talk about Picasso and Stravinsky, Hemingway and Pablo Neruda. Certainly Botero acquired enough basic knowledge from this circle of friends to be able to write an essay on "Picasso's non conformism in art." He was promptly expelled from school as a result. He supplemented his theoretical knowledge with practical experience. In the bull-fighting school, for example, which he attended at the wish of one of his uncles. Here,

Weeping Woman, 1949
Watercolor, 55 x 42 cm
Private collection

OPPOSITE:
Indian Girl, 1952
Oil on canvas, 185 x 150 cm
Private collection

though, he preferred the grandstand to the actual arena: he preferred depicting the dangerous business in pen-and-ink on paper to practicing it himself. Besides, he was able to sell his drawings with no trouble. He was soon earning his own money by providing illustrations for the daily newspaper *El Colombiano.*

Sometimes he would wander around the city with friends in order to paint in the open air. Medellín is a wonderful colonial city of great beauty, stretching out along a fertile valley. It lies like a precious gem in a setting of high mountains. Today Medellín is known as the headquarters of a drugs mafia that pulls the strings and overshadows the place with unimaginable violence and crime. The danger is so great that its most prominent son, Fernando Botero, can no longer go there. In his youth there was no drugs cartel. Medellín was best known then for the establishments in its red-light district. Botero and his friends used to paint the life of the city's bars and brothels too. Decades later, in distant New York or Paris, he was to commemorate them with large-format paintings and drawings such as *The House of Mariduque* (ill. p. 56), or *The House of Ana Molina.* These early, youthful painting excursions in Medellín and its environs left their mark on Botero's entire repertoire of motifs. For, to this day, all his works take sustenance from the memory of this world and its people, its landscape and its traditions.

In 1949 he painted a watercolor entitled *Weeping Woman* (ill. p. 7). It shows a crouching, unclad figure covering her face with disproportionately large hands. The woman's attitude and gesture express desperation, a feeling enhanced by the choice of colors, with its dominant black and blue. The Expressionist character of the painting is reminiscent of the reproachful pathos of Orozco, an attitude that also permeates the poetry of Cesar Vallejos. The latter's *Poemas Humanos,* with their central motif of rebellion and grief, reflected not only the general mood among South American artists at that time, but also the first artistic ideas

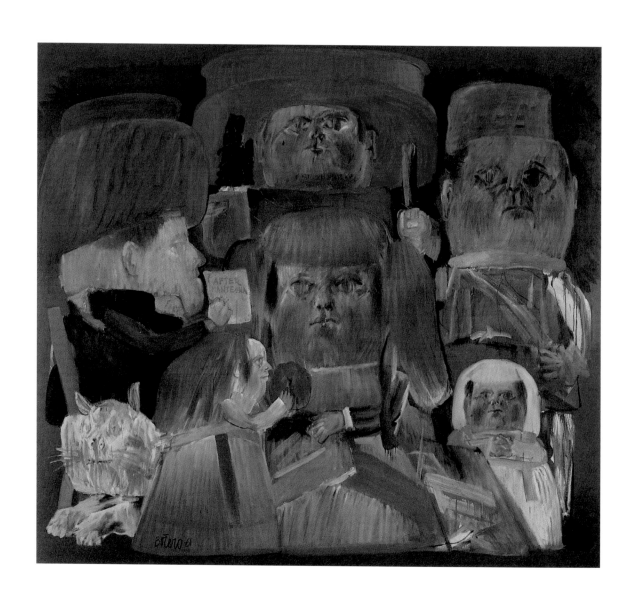

Camera degli sposi,
(Homage to Mantegna II), 1961
Oil on canvas, 232 x 260 cm
Hirshhorn Museum &
Sculpture Garden, Washington DC

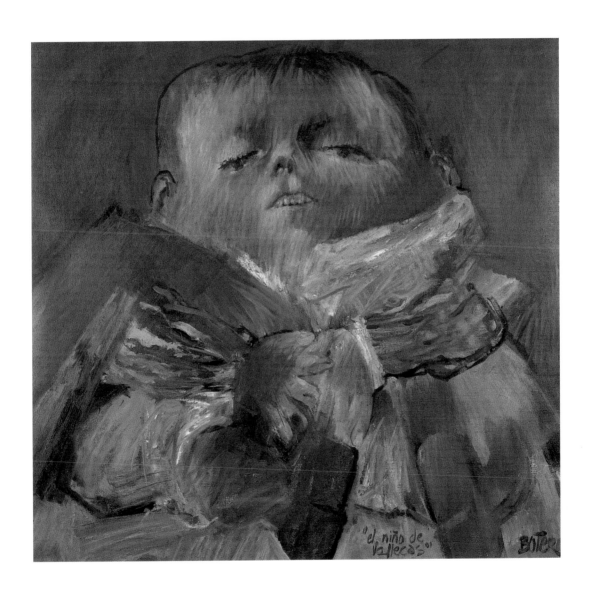

Child of Vallecas (after Velázquez), 1959
Oil on canvas, 132 x 141 cm
Private collection

Lost Girl in a Garden, 1959
Oil on canvas, 160 x 130 cm
Private collection

Figure in Profile, 1962
Charcoal on canvas, 226 x 184 cm
Staatsgalerie moderner Kunst, Munich

of the young Botero. As can be seen in the 1952 *Indian Girl* (ill. p. 6), there were other influences too, however: in this case clearly Gauguin with his peaceful South Seas pictures. Both works, the early watercolor and this oil painting, are among the few known pictures by Botero to date from this period.

In 1952 also Botero won the Second Prize at the Ninth Salon of Colombian Artists held at the National Library. Overnight this made the young man – not yet quite 20 years old – known to the circle of artists and intellectuals in Bogotá, and now too he had the money to pay for his passage to Europe on board an ocean liner. It was only here, and later in the United States, that he would after years of apprenticeship and traveling find the style for which he has become famous: those pictures that have become the hallmark of a modern Creole culture in Latin America and that in this respect can probably be compared only to the literature of Gabriel García Márquez or the music of Astor Piazzola. All three are linked by the existential experience of their origin and culture, which is central to all their work. At the same time, this work is of universal validity. Botero would say: precisely for this reason, "because the artist is universal only when he is firmly rooted in his own parish."

Another thing the three artists have in common is the popularity of their work. Botero has had over 50 solo exhibitions in museums throughout the world, from Tokyo to Washington, from Stockholm to Caracas. No painter in recent decades has exerted such a wide influence. As with the literary star Márquez, however, it is precisely this popularity that more often than not has been equated by the art world with commercial superficiality. But the contention that Márquez and Botero are really just continuing to exploit the long-gone Latin America boom of the 1970s really does not stand up to scrutiny. For in both cases their popularity goes hand in hand with quality of the highest order. They owe their "universal validity" not to the exotic-seeming contents and subject matters of their œuvres; rather, it rests primarily on the perfection of their artistic craft. Botero's work now comprises almost 3,000 paintings in addition to more than 200 sculptures and countless drawings and watercolors. It is a vast œuvre, which without a doubt stands up to critical examination.

But the young autodidact from the provinces who had never seen at first hand a painting by a master was still a long way from attaining his future status. Nevertheless he understood perfectly well the nature of the task ahead: like most South American artists before him, he had to leave his homeland in order first to discover the Old World and then, with a lot of luck, maybe to conquer it.

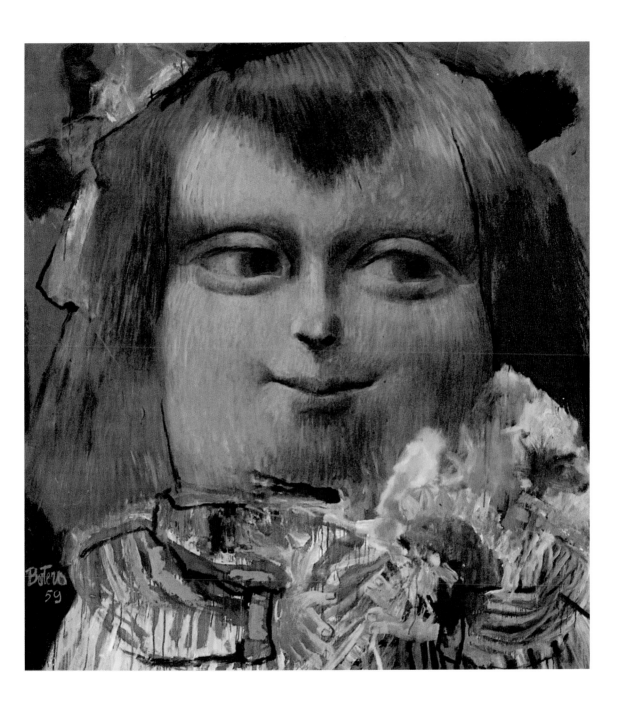

Mona Lisa at the Age of 12, 1959
Oil and tempera on canvas, 211.5 x 195.5 cm
The Museum of Modern Art, New York

Apprenticeship in Europe

The passengers on board the Italian ship on which the 20-year-old Botero left Colombia in 1952 were either disillusioned Europeans returning to the Old World, or, like himself, young South Americans traveling thither with great illusions of their own. In the early autumn he arrived in Barcelona, the city of the weird Antoni Gaudí and the young Picasso. He left it again within days, for his destination was the Spanish capital, Madrid, where he enrolled at the Academia de San Fernando to study painting. But he later declared that he did not learn much there, for while his teachers sought to help him find a style of his own, he was interested in the craft aspects. For this reason, this self-willed student preferred to spend his time in the Prado and there unravel the secrets of the Old Masters for himself. At first he copied the masterpieces – Titian's *Danae* to start with, then pictures by Tintoretto and, above all, Velázquez, whom he has revered all his life. Later he was to depict himself as Velázquez in black Baroque costume (ill. p. 64), to paraphrase his Infantas and dwarfs, and to learn continually from the aloofness and dignity that distinguished the work of the Spanish court painter.

Two semesters at Madrid were enough of an introduction to the art of painting for Botero; Paris beckoned – in the 1950s, the city was Europe's undisputed capital of the arts. It was here that Picasso and the other great artists of the time lived; here there were the great collections of modern art, which in Franco's Madrid did not exist. With a friend, the film director Ricardo Irragarri, he occupied a small apartment in the Place des Vosges for a few months, and soon discovered that here too he was attracted less by the artists' studios and the collections of modern art than by the great masters of the past in the Louvre and the well-sorted Parisian bookshops, where he loved to browse among the volumes of art history. More than anything else, he was interested by early Italian art.

In late summer 1953 Botero and Irragarri went to Florence. The experience was so overwhelming that he decided to stay in the city where the Renaissance was born, to study the technique of fresco painting. He enrolled in the Accademia di San Marco, but at the same time continued painting on canvas in his studio in the Via Panicale. It was in Florence that Botero studied for the first time not only the craft aspects of his art, but also the theoretical foundations. He followed with particular interest the lectures of Roberto Longhi on the art history of the Quattrocento and soon got to know the legendary Bernard Berenson. In

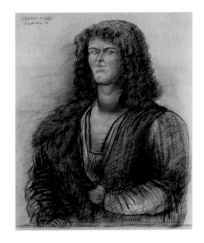

Oswolt Krel (after Dürer), 1969
Charcoal on canvas, 210 x 180 cm
Galerie Brusberg, Berlin

OPPOSITE:
Portrait of Pope Leo X (after Raphael), 1964
Oil on canvas, 150 x 130 cm
Private collection, Frankfurt a. M.

The Great Celebration, 1966
Oil on canvas, 117 x 147 cm
Galerie Brusberg, Berlin

his major work on Italian Renaissance painters, which had just appeared and immediately became a best-seller among books on art history, Berenson sought to "explain what the pictures by those artists have to say to us today, and what they, as lasting, life-enhancing present-day values mean to us." This book provided guidelines for the young Botero. Berenson's description and his analysis of individual Renaissance artists, the definitions of their styles and their artistic intentions, formulated very clearly what he was looking for during this Florentine period: the essence of tangible values, plasticity, the monumentality of the perspective outline. The extent to which Botero was influenced by Berenson can be seen in many of his statements on questions of painting, right up to the present day.

Among the other revelations for the young artist were Piero della Francesca's frescoes in Arezzo. The consummate form, the organization of space and the chromatic perfection that characterize Piero's works became the criteria by which Botero judged painting generally. At a time, then, when contemporary artists were attributing great importance above all to the painting gesture, the inner impulse and indeed to mere chance, Botero concerned himself with classical art and the solutions of figurative painting.

Excursion to the Volcano, 1966
Oil on canvas, 130 x 104 cm
Galerie Brusberg, Berlin

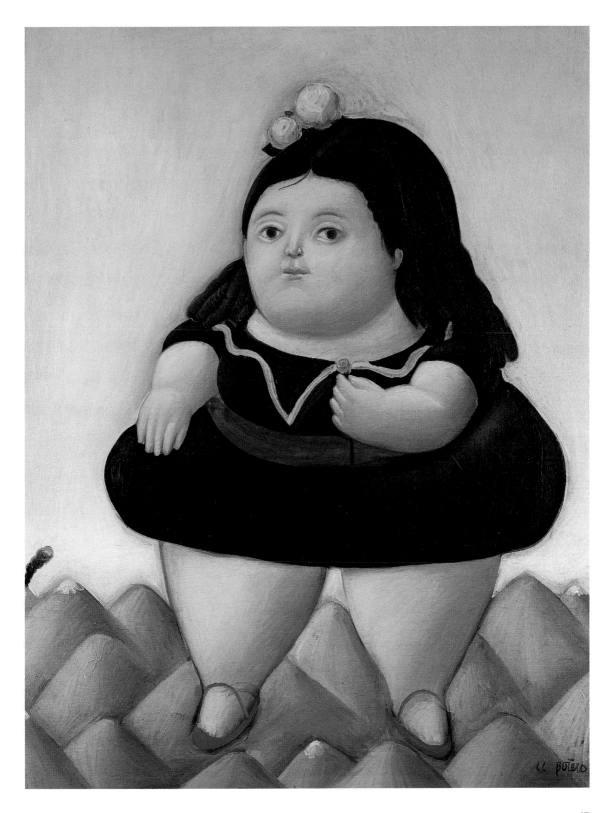

He explored Italy on his motorbike, being fascinated not only by Piero's frescoes in Arezzo but also by Giotto's work in Assisi and Padua. He visited Siena, studied Carpaccio, Giorgone and Titian in Venice, but was left largely indifferent by Baroque Rome. His exemplars were above all Piero della Francesca and Paolo Uccello. Botero admired their clarity and their mysterious calm, he loved the shadowless light and the geometric arrangement of volumes that can be found in the works of these early masters of the Italian Renaissance.

While in Florence, Botero painted several pictures of horses and riders, including one dating from 1953. The characteristic feature of this picture is the archaic simplicity reminiscent of Giotto, Piero and above all Uccello, whose *Battle of San Romano*, with its high horizon and the arrangement of the horses, he can only be said to quote. And yet, for all that, this is a 20th-century picture, seemingly not untouched by the Neoclassicism of de Chirico as well as the experience of abstraction. Even so, a marked individual style is not yet apparent in these pictures – instead only tendencies, as for example in the dry, fresco-like painting, and in the plasticity of the objects.

During the almost four years he spent in Europe, Botero visited museums, acquiring the standards and criteria he was to employ for his own work; he studied the techniques of the Old Masters and immersed himself in spiritual reflexion, in the philosophical dimension of art. This synthesis succeeded in Florence, where the works of Berenson and contact with Roberto Longhi, a friend of Carlo Carrá and Girogio Morandi, were particularly important. The aesthetic strategy behind his work was however not yet defined. "When one is young, one wants to put everything together. So did I. I wanted the color of Matisse, the construction of Picasso, the brushwork of Van Gogh." His Florentine experience marked the beginning of the search for coherence in his own work: it was here that the basic orientation began to develop which was to lead to his later work. In contrast to prevailing tendencies, it centered largely on a figurative art, which was to be both classical and at the same time an expression of his own age. Botero recognized that this coherence had to do with his background and his specifically South American roots. Thus in Europe he continually consorted with South American artists who, like him, were looking for something like a "South American" art. After two instructive years in Florence, the time had come to return to Colombia.

"In the case of Piero della Francesca I have understood the effect of tranquillity. We have a noble solemnity, which we can also observe in Egyptian art. I was always captivated by that. There are so many allusions in frozen movement!"
FERNANDO BOTERO

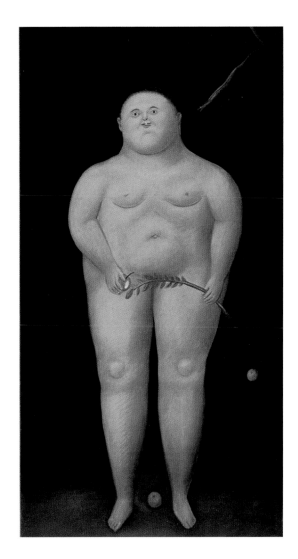

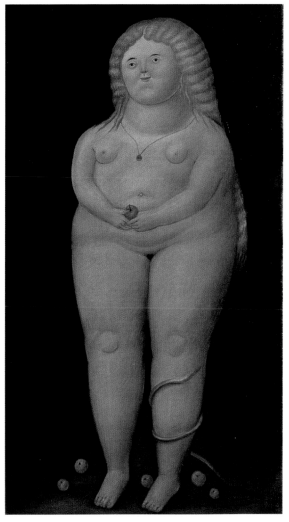

Adam, 1968
Oil on canvas, 195 x 102 cm
Private collection

Eve, 1968
Oil on canvas, 195 x 102 cm
Private collection

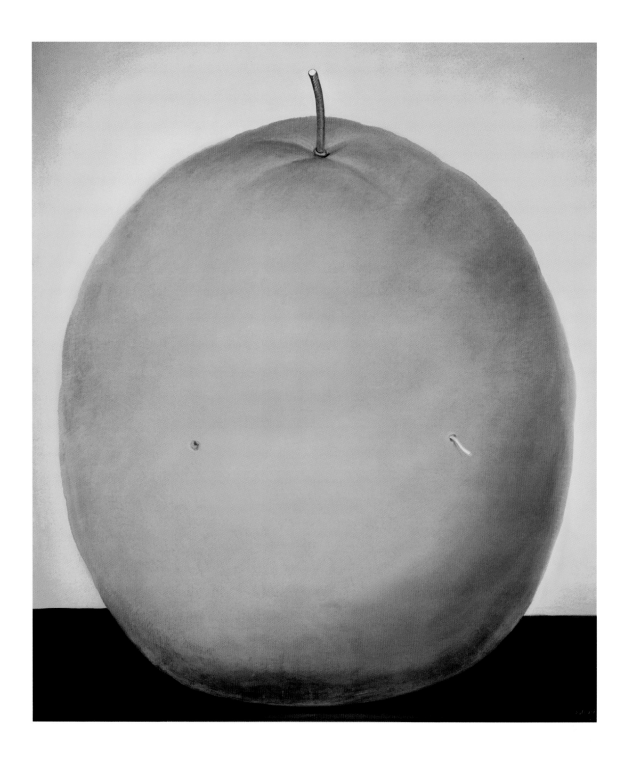

Mexico: The "Missing Link"
Mexico and Bogotá

In March 1955 Fernando Botero arrived back in Bogotá. It was a disappointing return, as soon became clear, for, in contrast to his earlier exhibitions, the pictures he had painted in Italy and exhibited in the National Library shortly after his arrival met with little interest. On the contrary, the public found them too classical, not modern enough, altogether "academic." For the first and only time in his life, Botero had to earn his living outside art, which he did by selling car tires – albeit only for a few months, for at the beginning of 1957, newly married, he went to Mexico, where he hoped to find the "missing link."

Culturally, Mexico was the leading country of Latin America. Here, the pre-Columbian civilizations had fused during the colonial period with the culture of the Europeans to form an inimitable, home-grown tradition, which had produced magnificent architecture, painting and sculpture. And no other country on the American continent had such a rich and varied folk art – and folk art, alongside the works of the masters, was always a source of inspiration for Botero. Even more than the "fine" arts, it is precisely folk art that reflects the essence of a culture. In addition, Mexico was the only country in Latin America that during the 20th century had produced modern artists who had achieved recognition abroad: Frida Kahlo, Diego Rivera, Alvaro Siqueiros and José Clemente Orozco were internationally respected artists, from whom Botero had hoped for the kind of impulses that Europe could not offer, and that he could not expect from other parts of the continent. Surprisingly, he was at first not enthusiastic about Mexican modern art. While he was attracted by the monumentality of the gigantic "murales," the Expressionist character of Orozco, and Siqueiros' politically inspired painting did not accord with his notions of art. On the contrary, they contradicted his sense of the calm, geometric tectonics of his compositional ideals and the formal elements of art. The writer Alvaro Mutis, whom Botero got to know in Mexico, later reported how, on walks together around Mexico City, Botero would suddenly stop to talk about Piero's compositional style or Giotto's blue.

And yet the encounter with the modern movement in Mexico left lasting traces in Botero's work. In almost all Latin American works of art, but in particular in Mexican revolutionary art, monumentality is an important category. It is deeply rooted in this cultural region, where it is not a fiction but an integral component even of its geography. No other painter had given it such convincing shape as Diego Rivera, who died in the very year that Botero arrived in Mexico.

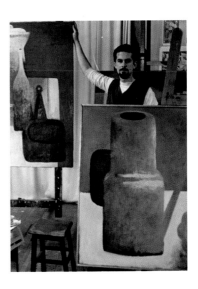

Botero in his studio 1957

OPPOSITE:
Orange, 1977
Oil on canvas, 195 x 225 cm. Private collection

Still Life with Mandolin, 1957
Oil on canvas, 66.7 x 121.3 cm. Private collection

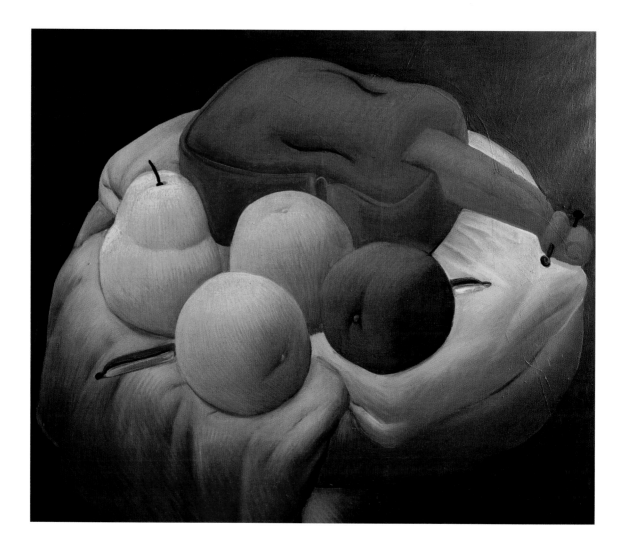

Still Life with Violin, 1965
Oil on canvas, 144 x 172 cm
Private collection

"For me, a personality like Rivera was always of the highest importance. He showed us young Central American painters the possibility of creating an art that need not be colonized by Europe. I was attracted by the mestizo quality, the mixture of old-established and Spanish cultures."

FERNANDO BOTERO

But his block-like, stereotypical figures, which take up almost the entire pictorial plane, were soon to be reborn in the works of Botero. Above all, Botero was impressed by Rivera's personality. He had created an art that was recognizable as the product of a particular time and a particular place, and that was what Botero too was endeavoring to achieve.

Botero was perhaps the only Latin American painter in the second half of the 20th century to have followed this example, for since the mid 1950s, artists from Latin America have increasingly oriented themselves to international developments once more: centers such as New York, Barcelona or Paris have become more important than Mexico or Buenos Aires.

Alongside the artistic influences, Botero's sojourn in Mexico was also important for the business side of his career. In contrast to Bogotá, there were professional galleries there. Doubtless the most influential at that time was that run by Antonio Souza, who was soon displaying Botero's pictures, arranging exhibitions of them abroad and occasionally selling them too – in any case in sufficient numbers to provide the artist with a livelihood.

The works dating from the early 1950s are now largely untraceable. Not even the artist himself possesses any photographs of them. One studio photograph dating from 1957 (ill. p. 21) shows the haggard young painter with two large still lifes. One depicts a single vessel, a kind of jug; the other several such. The stark presence of these objects is almost reminiscent of the still lifes of Giorgio Morandi – only here, the motifs are of gigantic dimensions. While the Italian artist, a master of subtle sophistication, was not interested in monumentality, but rather in the intimate dialogue between painter and object, these early pictures by Botero are impressive precisely because of their solid, earthy presence. In contrast to his later pictures, the proportions of the objects and their relationship to the surrounding space are here still basically geared to reality.

In late 1956 and early 1957, Botero painted some pictures for an exhibition held by the Pan-American Union in Washington. While working on *Still Life with Mandolin* (ill. p. 21) for this exhibition, he deformed the object to the extent that he depicted the opening of the somewhat large and heavy instrument much too small. This "disproportion" came as a revelation, because it led to a perhaps unconsciously sought key with which to enhance sensory presence of his objects.

Still Life with Pig's Head, 1968
Oil on canvas, 155 x 187 cm
Private collection

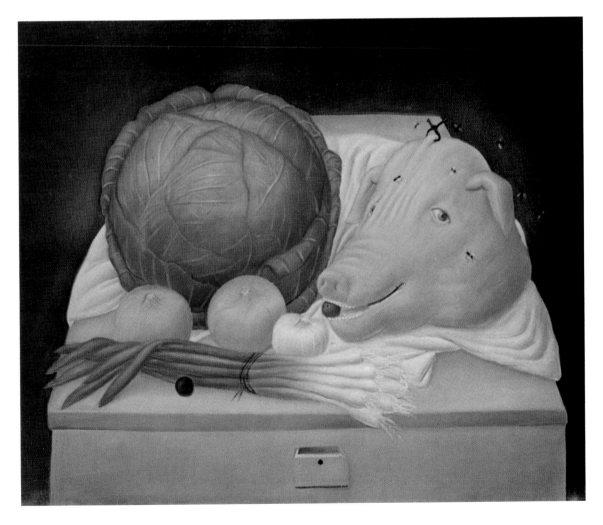

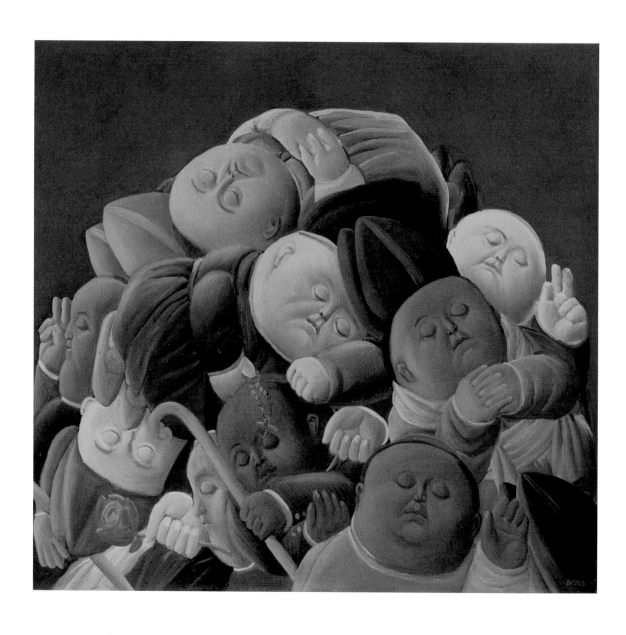

Dead Bishops, 1965
Oil on canvas, 175 x 190 cm
Galerie-Verein Munich; Staatsgalerie moderner Kunst, Munich

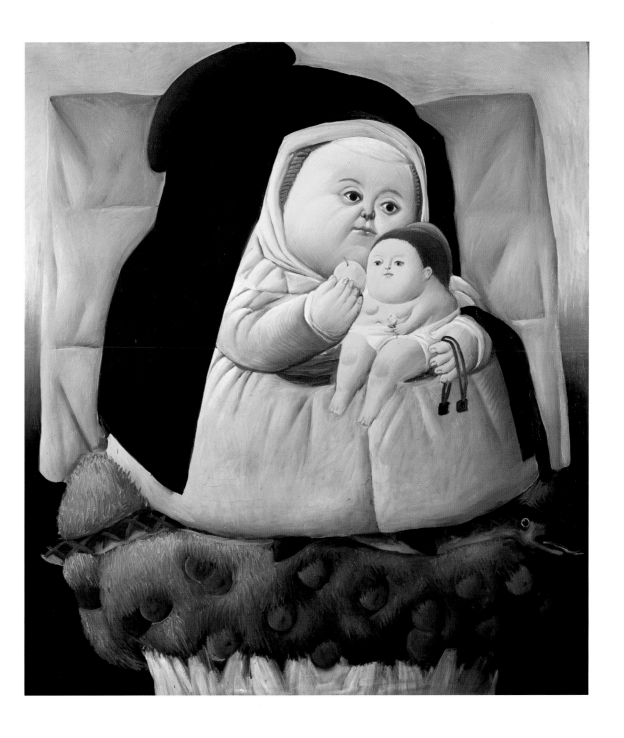

Madonna and Child, 1965
Oil on canvas, 187 x 165 cm
Private collection

Mother Superior, 1966
Oil on canvas, 82 x 76 cm
Private collection

La Dolorosa, 1967
Oil on canvas, 156 x 132 cm
Private collection

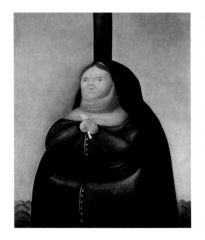

This simple technique suddenly gave the musical instrument a unique charisma, a luxuriant physicality. It was recognizable for what it was, but at the same time it was unreal, magical, generous. In a certain sense, this mandolin now also possessed a naive imperfection, comparable with the individual interpretation of the classical canon to be found in the colonial painting of South America.

In the following months Botero had his first solo exhibition in the United States, which was held in Washington DC in April 1957 under the auspices of the Pan American Union. The exhibition was discussed in the pages of the *Washington Post* by the art critic Leslie Judd, which may have motivated some of the employees of the Organization to buy one of the young Colombian artist's 30-dollar paintings. But more important for Botero than the sales was the opportunity to become acquainted with contemporary American art. Already in Florence he had heard the names Jackson Pollock and Willem de Kooning, but until now he had not seen any original works by these artists. Now he was able to study them in the museums of Washington and New York. This encounter with Abstract Expressionism, this gestural, nonfigurative painting on huge canvases, triggered a deep crisis, for it was precisely the opposite of what Botero with infinite patience had learned in the museums of Europe. Fortunately he had made the acquaintance of the gallery owner Tania Gres, who provided him with moral and financial support during these weeks in Washington.

Botero then returned from Washington via Mexico to Bogotá for a few months – with the New York avant-garde and the Mexican modernists in his intellectual luggage alongside the art of the Renaissance and the New World Baroque. It was pleasant to be fêted in his homeland as already the most important of the new generation of artists, and at the age of 26 to be appointed professor of painting at the Academy.

Thus his self-confidence soon returned, and he painted for hours each day with great pleasure. In the next three years, his figurative painting developed its unmistakable style. He painted pictures of young girls, whole series of voluptuous half-figures, owing no less a debt to the idols of the Maya and the Aztecs than to the mysterious *Mona Lisa*. He also painted narrative pictures with scenes of everyday life, such as the *Apotheosis of Ramón Hoyos* (ill. p. 8), an unusual subject, a kind of modern historical picture dedicated to a contemporary hero, a Colombian cyclist very famous at the time. In Bogotá Botero also began to paint paraphrases of famous pictures in European museums, which form an important component of his œuvre. During this period he executed more than ten versions of Velázquez's *Niño de Vallecas* (ill. p. 11), alongside a number of versions of Mantegna's *Camera degli sposi* (ill. p. 10) and the series of *Mona Lisas*. It was with his picture of *Mona Lisa at the Age of 12* (ill. p. 13) that in 1959 Botero – together with two other Colombian artists – represented his country at the São Paolo Biennale.

Botero was prompted to paraphrase this motif, in exemplars from art history on the one hand by their familiarity: "These themes are important to me to the extent that they are popular and have become more or less common property. Only then can I do something different with them. Sometimes I simply want to understand a painting more fully and deeply, its technique and the spirit that animated it." On the other hand, he wanted to use the paraphrases to show that the most important aspect of a painting is not the theme, but the style. Thus his huge *Montefeltro diptych* of 1998 (ill. p. 72–73) is quite different from that of Piero in the Uffizi. It is the work of a 20th-century Colombian and not of a Renaissance Florentine.

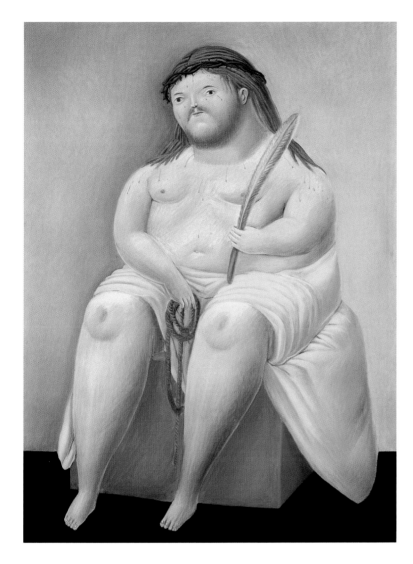

Ecce Homo, 1967
Oil on canvas, 194 x 141 cm
Private collection

In the ensuing decades Botero was to put his own mark on such icons of art history time and again, and in this way create such fascinating pictures as *The Arnolfini Marriage* (ill. p. 70) after van Eyck or a *Mademoiselle Rivière* (ill. p. 71) based on Jean-Auguste Ingres.

With time Botero's figures and objects became more sculptural, the volumes swelled and the formats increased in size – maybe under the influence of the New York avant-garde. In 1958 he painted *Sleeping Bishop* as well as *The Martyrdom of the Bishops*, his first clerical motifs in a long series of pictures on this, by 20th-century standards, unusual theme. They were soon followed by equally "unmodern" legends of saints, such as *The Miracle of Saint Hilary* dating from 1960. His unfamiliar, emphatically horizontal picture format goes back to the "predella" of early Italian altar pieces, where they provided the necessary space for the narrative depiction of the legends. Botero likes to paint pictures of clerics and church dignitaries, because they reminded him of Italian painting: "I was permeated by and in love with the painting of the Quattrocento. Though of

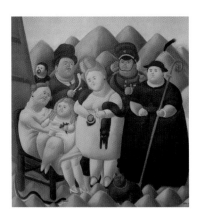

The Presidential Family, 1967
Oil on canvas, 203.5 x 196.2 cm
The Museum of Modern Art, New York
(Gift of Warren D. Benedeck 1967)

course I am not a man of that age, but of the 20th century. Priests somehow belong in both eras."

Admittedly, these otherwise no longer common motifs allowed Botero also to depict a specifically Latin American reality. For of course they allude to the importance of the Church as an institution and identity-bearer in this region. The Church and its representatives are a part of life here more than they are elsewhere. They put their stamp on social, human and political relationships, and are part of the public inventory of its small towns and villages.

When these pictures were painted, they were at first interpreted as being critical of this ancient institution. But in fact they are more like a mild, forgiving smile at the harmlessness of its bigotry. In any case, as he developed, Botero was to reveal himself as more of a loving than of a critical painter. His irony has always also had more than a pinch of friendly ingredients, or else the criticism is decidedly muted, as in the early picture *Dead Bishops* (ill. p. 24). It is rumored to allude to the role of the Church in violent political disputes in Colombia during the 1940s.

Botero's debut in the United States was followed a year later, in 1958, by a second exhibition in Washington DC, this time in the gallery run by Tania Gres. It was his first gallery exhibition in this country, and it was a great success. Almost all the pictures were sold as soon as it opened. For the first time, moreover, a Colombian was exhibiting in an international context, for the gallery – which sadly closed after a few years – also featured the work of such artists as Louise Nevelson, Karel Appel and Antoni Tàpies.

Among the pictures Botero sent to the United States capital for this exhibition were *Camera degli sposi* (ill. p. 10), based on Mantegna, and *The Apotheosis of Ramón Hoyos* (ill. p. 8). The works of these years, of which these two pictures are typical, are probably among those that are most closely associated with the international art of the time. It is true that their subject matter is very unusual in this connection, but the painting rhythm, and the relationship of figure to space, build on styles ranging from Cubism to Abstraction.

Thus the heads in *Camera degli sposi*, for example, which are arranged either frontally or in strict profile, cover the canvas like an open-meshed net and create something resembling blocks of shape and color in an undefined space. Later, Botero was no longer to paint spaceless compositions of this kind, because they constrained the plasticity and three-dimensionality that was becoming more and more important to him.

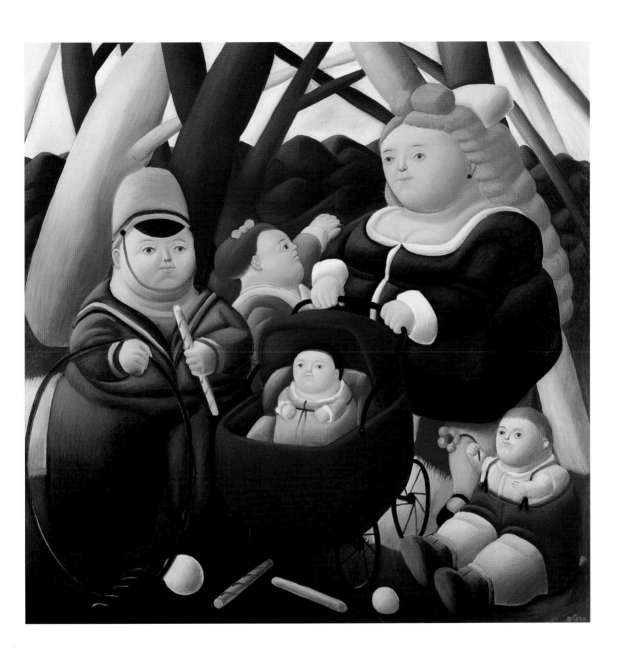

The Rich Children, 1968
Oil on canvas, 98.1 x 195.6 cm
Private collection

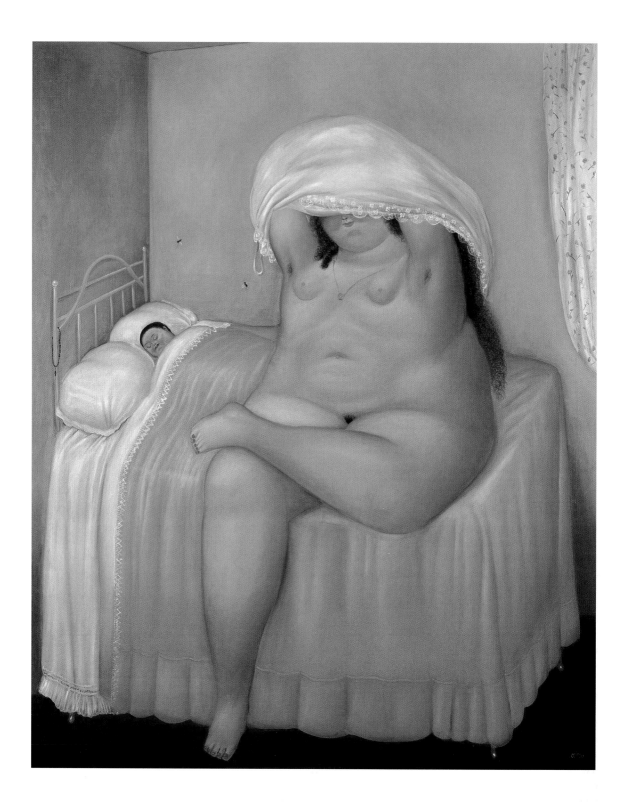

The Challenge of New York

On the occasion of a second exhibition at the Gres Gallery in October 1960, Botero traveled once more to Washington, DC. He soon realized that he would have to stay in the United States if he wanted to make any headway as an artist. This was a difficult step for him, because it meant once again leaving his achievements behind – and one casualty was his first marriage, which was dissolved shortly afterwards.

With not much money, and not much English either, Botero took a modest apartment in Greenwich Village, where, as he likes to report, he started to paint on the day after his arrival. It was lonely working in the studio, and he was also alone when he visited museums and galleries, and went on endless wanderings through the streets of the huge, unforgettably cold city: these were for him the lasting memories of the winter of 1960/61 and his early days in New York. At the same time he was inspired – by the energy of the place, and by the feeling of being in competition with other talented artists – to take up this gauntlet.

At no other point in his career did the artist have to give so much of his best in order to survive as he did in New York. In this respect, the early years in the United States were no less formative than his European apprenticeship. And here too Botero demonstrated the power of resistance that was always his hallmark and was the decisive factor in his success. The vortex of current styles, Abstract Expressionism and Pop Art – Lichtenstein and Warhol were then exhibiting their first works – did not deflect Botero from his path, which he saw as the expression of Latin American culture and its origins.

The New York years were the hardest in his life: scanty meals, loneliness, rejection, devastating critiques – and in any case, "Latinos" (or "Hispanics" as we should now say) formed a low-status community in this environment.

But there were bright spots, like for example the 1961 Guggenheim International Award, which Botero won for his painting *The Battle of the Arch-Devil*. And then in 1963 the prominent display of his *Mona Lisa at the Age of 12* (ill. p. 13) in the foyer of the Museum of Modern Art as a humorous parallel to the display of Leonardo's own *Mona Lisa* at the Metropolitan Museum. Alfred Barr, then Director of the Museum of Modern Art, had acquired the painting a few months earlier on the advice of his curator Dorothy Miller, and it was the only contemporary figurative painting bought by the museum that year. The honor of having his work purchased by the museum, along with the spectacular

Fernando Botero in his New York Studio, 1966. In the background the painting *Our Lady of New York*.

OPPOSITE:
The Lovers, 1969
Oil on canvas, 190 x 155 cm
Galerie Brusberg, Berlin

31

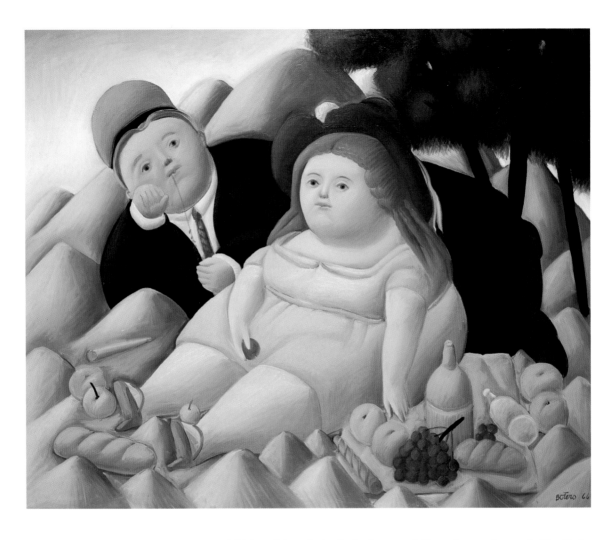

Picnic in the Mountains, 1966
Oil on canvas, 150 x 180 cm
Private collection

"My kind of figurative art derives in a certain sense from the experience of abstraction. It is not the same kind of figurative art as existed in pre-Abstraction times. For example, my compositions are based on laws of colour and form, so that I often stand a painting on its head in order to perceive it as an abstract work. As a consequence of the abstract experience, form and colour have to be composed freely. I need total freedom where proportions are concerned. If I need a small form somewhere in a picture, for example, I can reduce the size of a figure."
FERNANDO BOTERO

exhibition of the painting in the foyer, made Botero's name famous in New York overnight.

His acquaintance with Marina Ospina, a friend from Colombia, who had also studied art in Florence and was now working in New York as assistant to the Austrian photographer Ernst Haas, opened further doors into the art world, and among others, Botero got to know Willem de Kooning, Franz Kline, Jackson Pollock and Mark Rothko, the four leading members of the New York Abstract School. He was inspired by their sweeping painterly gestures, by their freedom and by their standards as artists. For him, this admiration meant not so much a direct influence on his artistic style, as that he sought to learn something from their attitude. Unlike many now forgotten South American artists, Botero swam "against the tide," in that he held fast to the idea of a monumental figurative art that he had developed in the museums, and to his Latin American roots.

The pictures painted by Botero during his early years in New York when plagued by great loneliness and considerable material deprivation are among his most beautiful works. They include first of all the so-called *Niñas*, pictures

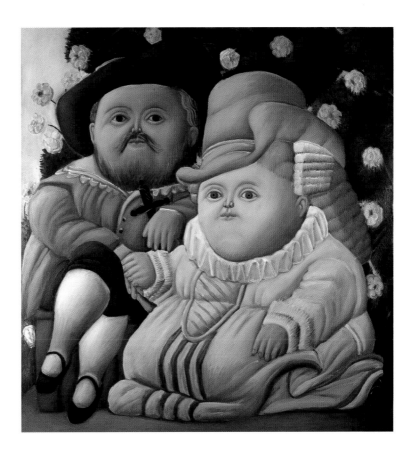

Rubens and his Wife, 1965
Oil on canvas, 198 x 186 cm
Private collection

depicting just one girl. Always on a very large canvas, her huge head, either full-face or in profile, almost entirely fills the picture, with so little room between it and the edge that the beholder almost feels he or she is looking at it through a magnifying glass. The faces are painted with great accuracy using fine, mostly vertical brushstrokes, while the small bodies of these *Niña*s are free both in their proportions and their painting techniques. It was the only time that Botero worked using a spontaneous approach, doubtless under the influence of the New York school, of which the color spectrum is also reminiscent. The free brushwork is what gives life to these Stoic, highly sculptural and, in their lack of emotion, altogether doll-like creatures. He was never to abandon this serene, relaxed type of figure. Individuality, emotion, unrest – Botero rejected these on principle, which was also why he never worked from life or with the object in front of him, but always freely from memory. Painting was, he said, "a world of its own. A still life is not a botanical engraving. The issue is not the fruit, but the picture. The same goes for men and women."

In about 1963 Botero took a more spacious studio in New York's Lower East Side. It was here that he painted a series of gigantic, but friendly, decked out creatures with gentle, round contours. Their soft, sensual, velvet skin covers their ample bodies within which, buried deep in the flesh, their small but always good-natured souls seem to be slumbering. To the question of whether his figures had light souls, Botero once replied on a later occasion: "They never wanted to have souls!"

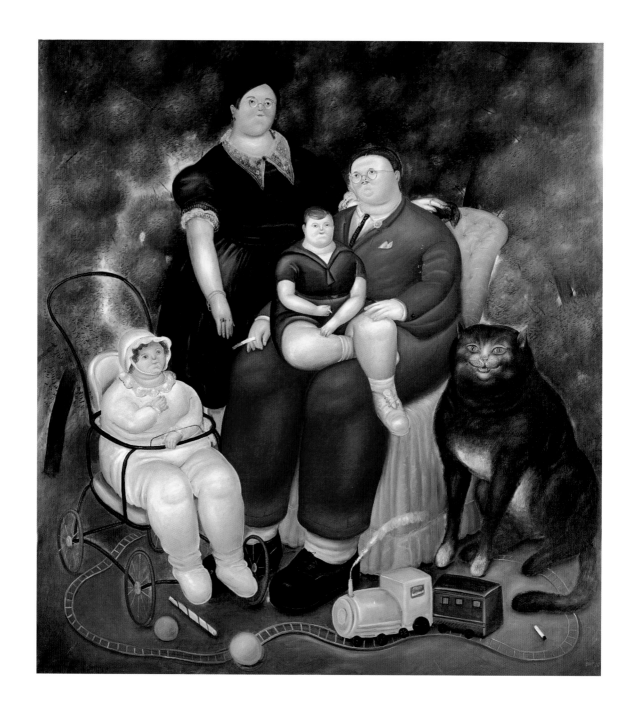

Family Scene, 1969
Oil on canvas, 211 x 195 cm
Private collection

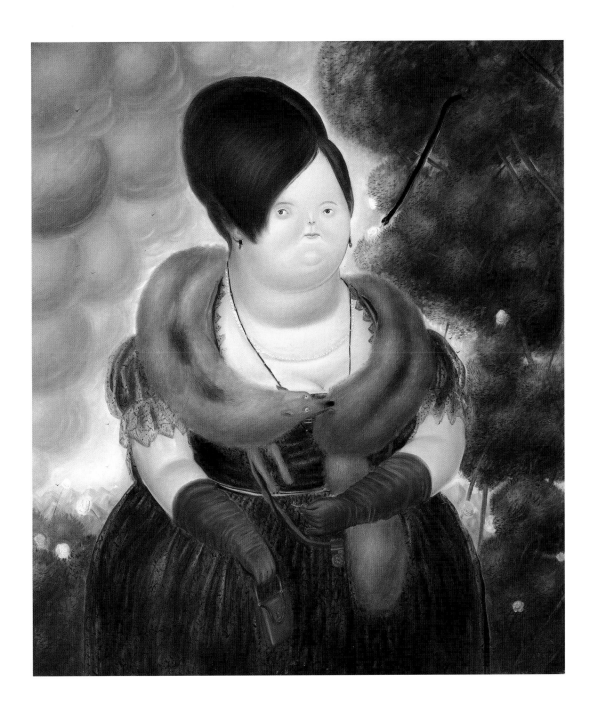

The First Lady, 1969
Oil on canvas, 198 x 173 cm
Private collection

The Pinzón Family, 1964
Oil on canvas, 170 x 170 cm
Private collection

The traces of the painting process gave way in these years to a smooth, formative painting technique, for which Botero preferred pale, subtle colors. In about 1965 the basic formation process was complete: the artist had found his figurative style, his world of motifs and his aesthetic concept. Hand in hand with this artistic development came the beginnings of financial success. A number of galleries took an interest in Botero's works, while he sold other pictures direct from the studio. In 1964 this situation allowed him to start building a summer house on Long Island, where he was able to work in ideal conditions. During this period, for example, he painted the picture *Standing Girl*, perhaps a final variation on the earlier *Niña* theme. It is a picture that, while not directly quoting Velázquez, is informed by the spirit of the Spaniard's Infantas. "I have always sought the sublime, and venerated Velázquez, because he avoids any emotional commentary. I admire this aloofness, this dignity." Thus Botero on the Spanish painter, whose works he had studied above all when he first arrived in Madrid from Colombia.

Unlike Pop Art pictures, Botero's painting is timeless: there is nothing to remind us of the 1960s, of the frivolity of the world of commodities and consumption. No girl of that decade wore her hair like that, or a dress like that, let alone a hat. Botero's *Niña* is a picture drawn from memory, it is his vision of a girl in art. The same is true of other works by Botero dating from this period: the *Portrait of Pope Leo X* (ill. p. 14) for example, a paraphrase after Raphael, or of a *Still Life with Bottle*. Perhaps in connexion with his second marriage, in 1965 Botero painted *Rubens and his Wife* (ill. p. 33) based on the famous work of the Flemish painter in the Alte Pinakothek in Munich. These pictures are characterized by a curious innocence: their formal language is reminiscent of American Spanish and Creole provinciality with their harmless poetry – and especially in works such as *Madonna and Child* (ill. p. 25), dating from 1965. If we look at this picture in the context of nineteen-sixties' New York Pop Art, we can see how it must have had an altogether shocking effect. With her child, the bell-shaped Madonna sits on an apple-tree as if on a nest, or a throne. From beneath her compact gown, a snake peeps out – but apart from that, Botero takes the greatest pleasure in adding everything that traditional iconography assigns to Madonna pictures: the child, apples, a halo. This un-self-conscious handling of a motif that belongs to the tradition both of fine art and of folk art derives unambiguously from Latin American painting during the colonial period, which was one of Botero's sources no less than was the art of the Italian Renaissance.

Botero's themes during the first few years in New York were still lifes, families – for example the well-known *Pinzón Family* dating from 1964 (ill. p. 36) – cardinals, nuns and children. Thus he had already developed not only almost his entire repertoire of motifs, but also such important stylistic elements as the type of figure. Whether he is painting a girl, a bishop or a Madonna, the protagonists of the pictures are prototypes with variations. Large, tranquil forms, painted from memory, among them memories from art history, from life in the Colombian highlands, or from the colonial painting tradition – themes, in other words, that had no relationship with contemporary New York or its art scene.

Public incomprehension was accordingly great; critiques were negative and often hurtful. The magazine *Art News,* for example, wrote that: "Botero's creatures are fetuses fathered by Mussolini on a simple-minded peasant woman," while his work was written off elsewhere as "provincial Baroque kitsch."

Things began to change in early 1966. Slowly appreciation of his painting began to grow. In retrospect, this year can be seen as an extraordinarily

Woman, 1978
Pastel on paper, 109 x 95 cm
Galerie Brusberg, Berlin

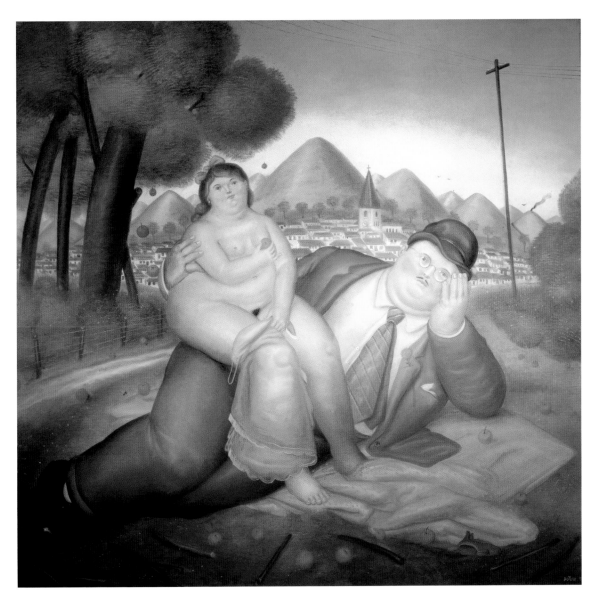

Loving Couple, 1973
Oil on canvas, 183 x 190 cm
Private collection

Botero calls this picture *Loving Couple,* but is that what it
really depicts? Is the woman really the lover of the respectable
recumbent spectacle-wearer in the pose of the thinker?
It could also be an Eve, who was created from one of his ribs
and seduced him, and whom he has been condemned to
desire ever since. There are no clear answers to questions
like these such as may be asked by a beholder, Botero's
pictures keep their secrets.

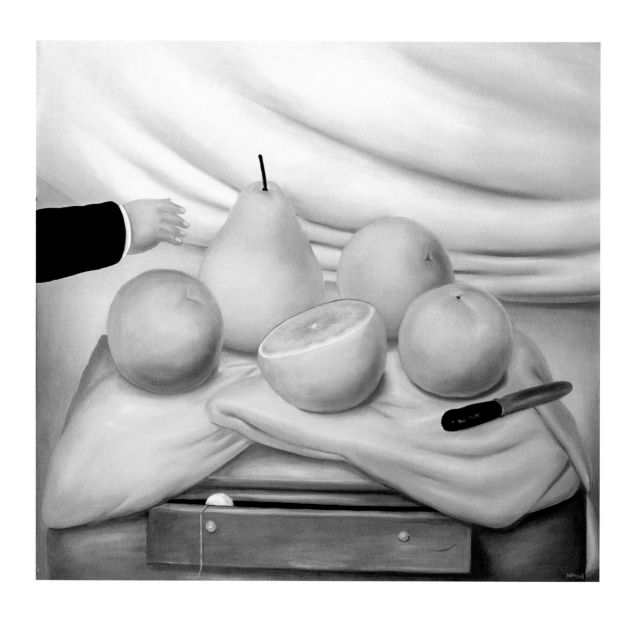

Still Life with Fruits, 1978
Oil on canvas, 176 x 191 cm
Private collection

***Frank Lloyd and his Family
on Paradise Island,*** 1972
Oil on canvas, 234 x 192 cm
Private collection

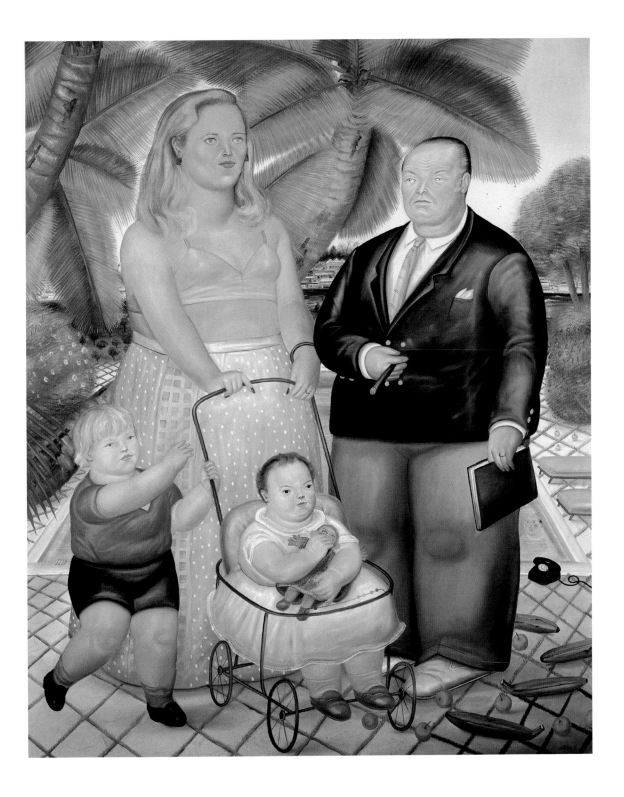

Child of Vallecas (after Velázquez), 1971
Oil on canvas, 174 x 126 cm
Private collection

important one for Botero. It started with an exhibition in Germany, at the Kunsthalle in Baden-Baden, which later moved to the Galerie Buchholz in Munich. Gudula Buchholz, who herself comes from Colombia, put Botero in touch with Dieter Brusberg, who in September that year staged his first Botero exhibition in Hanover, and who is still to this day one of Botero's major dealers.

On the occasion of this exhibition in Hanover, the art critic Gottfried Sello wrote in the German weekly *Die Zeit*: "Botero is the most interesting South American painter we have seen in Europe for many years. After this debut, he can be certain of a great career. Botero paints over-sized figures and heads, bloated, inflated monumental monsters, which come across as childish and ridiculous, whose corpulence swills over the frame, and are painted in the virtuoso manner of the Old Masters. A satirical homage to Rubens is the double portrait of *Rubens and his Wife*, the painter with his legs delicately crossed, at the moment before he drowns in his own fat. He paints not only his portrayals of *The Pope* or *Saint Sebastian*, but also simple still lifes with apples or wine bottles, and even the portrait of a cat, with the same ironic brutality". Other German newspapers also discussed the first Botero exhibitions in Germany in altogether positive tones. The daily *Die Welt* wrote: "Botero's creations form an eerily abyssal mixture of Naivity and Mannerism, idyll and nightmare. Is he sometimes a critic of the times? Does he send up religion and the Church? Titles such as *The Pope, Saint Sebastian* and even *Jesus Christ* for some of his obese, sphere-headed creatures would seem to suggest this. Yet everything remains many-layered and encrypted, perhaps only a quasi-ironic motif, South-American style. In addition there are still lifes, no less gigantic and solemn, with old tea pots and wine bottles, whose silent monumentality bears witness to a sense of order that has no need to concern itself with alleged relevance." All in all, the first exhibitions in Germany went down well both in the press and with the public, and among collectors – the mysterious South American was on everyone's lips overnight.

The year 1966 ended with a solo exhibition of 24 pictures at the Milwaukee Art Center: this exhibition led to Botero's breakthrough in the United States too. While the art critics were cautious in their judgement, *Time Life Magazine* printed a long report about the exotic painter from Colombia and his "fat people," a report that made him known to a broad public.

Since then, the press has not stopped reporting on Botero, his pictures, his sculptures and his various places of residence. All the major magazines in Europe, North and South America, and Asia have devoted countless column-inches to him, more than to any other artist in the last 50 years. The art critics by contrast have been restrained, although even in the mid-1960s his works had already found their way into the collections of the Metropolitan Museum, the Museum of Modern Art and the Guggenheim, as well as the Staatsgalerie moderner Kunst (now the Pinakothek der Moderne) in Munich. The reasons for this reticence are many and varied: Botero could not, and still cannot, be categorized into any one tendency or school; his absolutely individual, subjective works have from the very beginning flown in the face of every zeitgeist, they are non-political, they have always been "appetizing" fare, and thus suspiciously undemanding. Also suspect is the fact that Botero has earned a lot of money with them. And on top of all that is the fact that his gods are not Picasso, Duchamp or Pollock, but the masters of bygone ages from Velázquez to Bonnard, and his Parnassus is the Louvre, the Prado, the Metropolitan. And finally there are the anachronisms of his pictorial repertoire: Botero's figures do not live in modern times, they do not

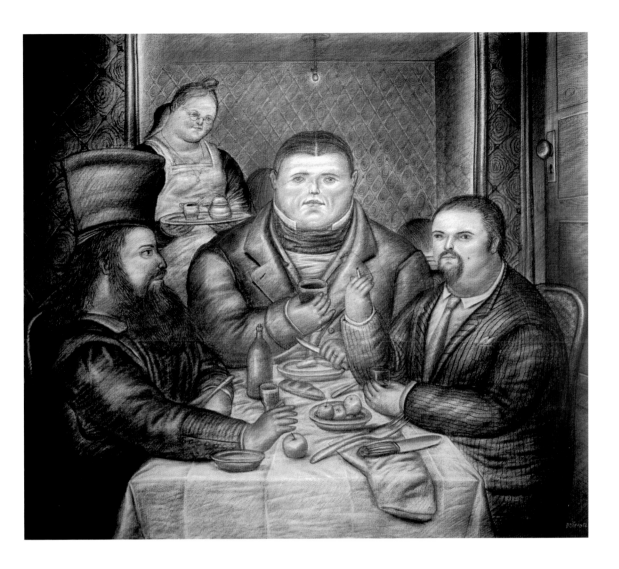

drive cars, they do not meditate on their existence, but simply exist, as a cat or a poodle exists; they come from the provinces and do what people have always done in the provinces: they eat, they drink, they make love, they go for walks, they raise their hats, they dance, they sew, they shed tears, they go for picnics.

By the late 1960s, Botero had definitively consolidated his style. The form, content, manner and themes of his work would no longer undergo any fundamental alteration, only here and there would there be changes in emphasis, and with advancing age, occasionally in mood.

The key pictures of his œuvre were painted during this period, starting off with the more austere, such as *Excursion to the Vulcano* (1966, ill. p. 17), *Picnic in the Mountains* (1966, ill. p. 32) or *The Rich Children*, dating from 1968 (ill. p. 29), and then, towards the end of the decade, more complaisant examples, such as *The First Lady* (ill. p. 35) or a further *Family Scene* (ill. p. 34), both from 1969. His forms now tended towards a greater naturalism, the colors are brighter, more transparent, more French. And time and again he turns to art history, sometimes

Dinner with Piero and Ingres, 1968
Charcoal on canvas, 166 x 193 cm
Private collection

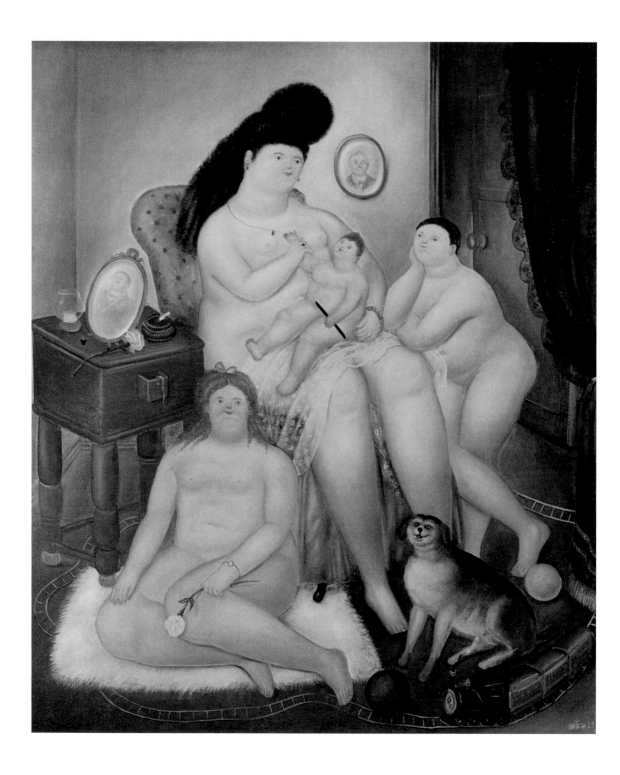

OPPOSITE:
Protestant Family, 1969
Oil on canvas, 209 x 175 cm
Private collection

Man Going to Work, 1969
Oil on canvas, 182 x 185 cm
Private collection

in the form of a direct paraphrase, as in the case of the *Mademoiselle Rivière* (see ill. p. 71), or simply by taking up a genre, such as the family portrait, which Botero, following Flemish and English examples of the 17th and 18th centuries, was probably the only 20th-century painter to have mastered so convincingly.

During this period exhibition enquiries also began to accumulate, and a triumphal march is the only way to describe the touring exhibition of 80 pictures that started in the Kunsthalle in Baden-Baden in 1970 and went on to visit Berlin, Düsseldorf, Hamburg and Bielefeld. Its success also aroused the interest of private galleries. The Marlborough Gallery in New York, which signed a contract with Botero in 1971, was of particular importance in the development of a market for his pictures. Its former proprietor, the legendary Frank Lloyd, was painted by Botero not as an influential and enterprising art dealer, but as a husband and father in the garden of his house on Paradise Island near Nassau (ill. p. 39). As Botero tells it, the cigar-smoking bon viveur evidently conducted his business on the telephone, which can be seen on the edge of the pool, though depicted no larger than the child's doll or the fruit lying on the ground. Botero presents us with a private family portrait probably as attractive as any to have been painted during the 20th century.

The connection with the Marlborough Gallery brought Botero not only considerable financial gain, but also enormously enhanced both his popularity and celebrity – in parallel incidentally with his fellow-Colombian Gabriel García Márquez, whose 1967 novel *One Hundred Years of Solitude* was a worldwide success and marked the beginning of a Latin-America boom in literature, which continued into the 1980s.

Until 1973 Botero lived exclusively in New York, but made frequent trips to Europe, Colombia and Mexico. He visited Germany, which had given him such a positive reception, several times. The fruits of these journeys consisted of an impressive series of large-scale charcoal drawings on canvas in the manner of Albrecht Dürer, hence the name "Dürer-Boteros." Botero enjoyed returning to

The Botero Exhibition, 1975
Oil on canvas, 52 x 196 cm
Private collection

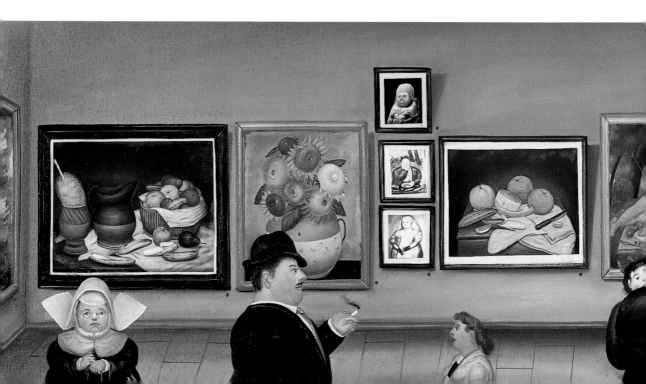

this particular technique, because it allowed him to concentrate more intensely on draftsmanship, the line. He always liked these "finger exercises."

The charcoal drawing *Dinner with Piero and Ingres*, dating from 1968 (ill. p. 41) is altogether programmatic. It is a composition in the tradition of the artist-and-friendship genre as invented by Rubens in his painting *Justus Lipsius and his Friends*, now in the Palazzo Pitti in Florence. Like Rubens, Botero here paints himself at the table in the relaxed company of masters whom he admired, and with whom he felt a spiritual bond. The three painters have just finished their meal, one of them has raised his glass once again, the other is lighting a cigarette, while a young woman serves coffee. It is a meeting of friends that transcends the centuries, and one in which the Colombian presents himself as a colleague on equal terms with the two famous masters. In the history of art, Piero and Ingres stand for a kind of painting characterized by precision of draftsmanship and geometrically balanced composition, a kind of painting in which no brush-stroke is superfluous or anarchic, but where everything follows a concrete and aesthetic ordering principle. They both represent a classical art based on formal mastery, an art that celebrates elegance and sophistication – in contrast to the visionary, irrational art that, from Hieronymus Bosch to the Surrealists, belongs to a different tradition. Another fascinating aspect of this dinner is Botero's unmistakable style, which finds its expression in the stolidity and deformity of the objects: they are far too small for the voluminous figures. Thus we have the charming impression of effort and clumsiness, which, for all the virtuosity of Botero's draftsmanship, is also reminiscent of the Latin American art of the colonial period and the 19th century.

PAGE 46:
Hommage to Bonnard, 1973
Oil on canvas, 248 x 187 cm
Private collection

PAGE 47:
Hommage to Bonnard, 1972
Oil on canvas, 234 x 178 cm
Collection Aberbach Fine Art, New York

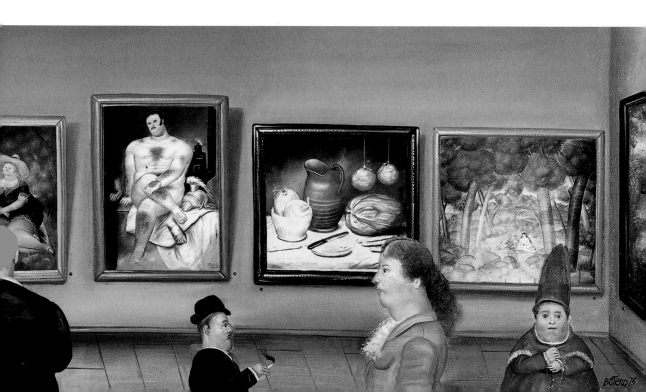

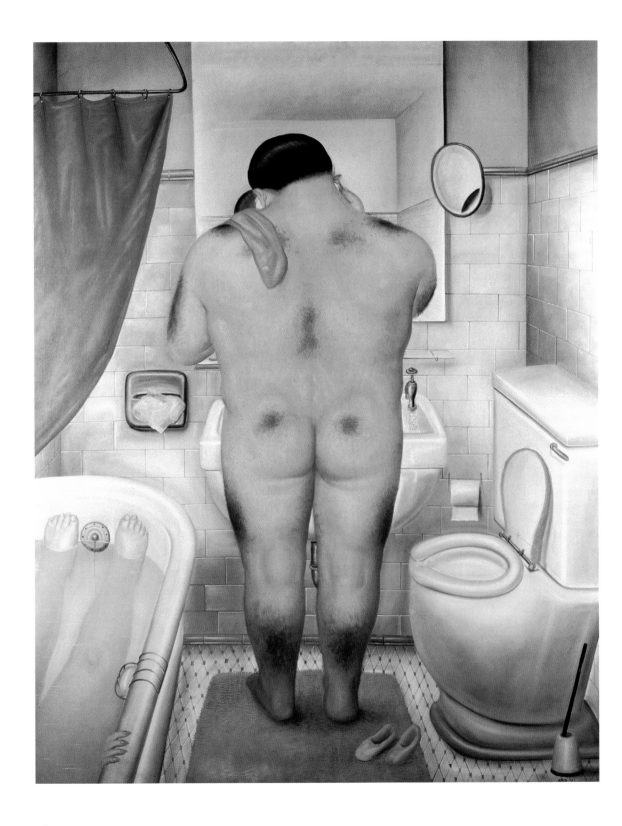

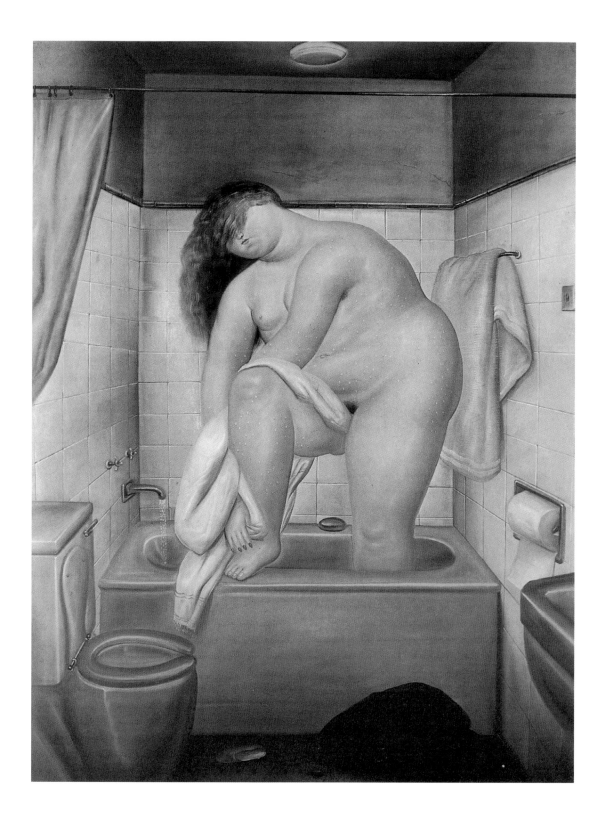

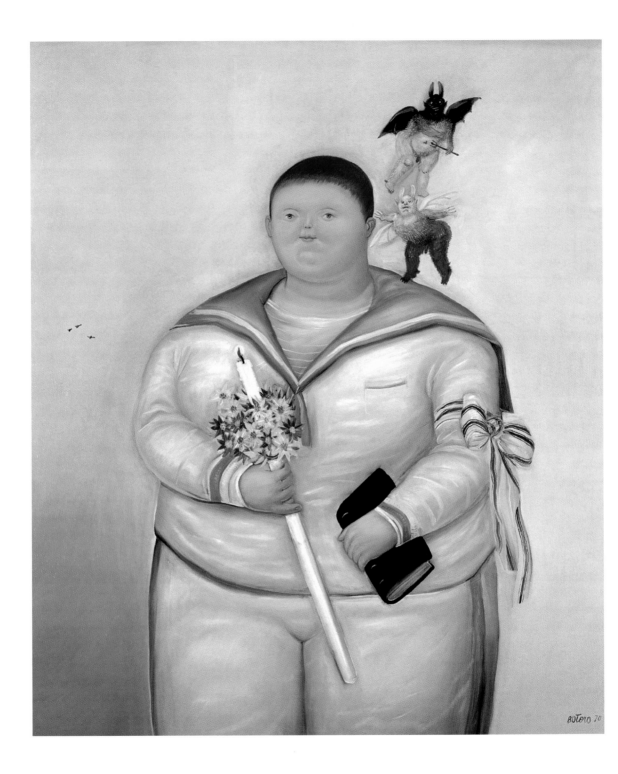

Why Does Botero Paint Fat People?
Deformation as a Formal Principle

"No, I don't paint fat people," is how Botero answers this question time and again, a response that comes across at first as confusing and provocative. For of course the figures we encounter in his paintings are not anorexic or half-starved; they are altogether well-fed and chubby, in some cases downright corpulent. But then again it is not only the figures that are "fat," but all the other things in the pictures too. And in this way Botero constantly emphasizes the fact that in his pictures exaggeration springs from aesthetic unrest, and has a stylistic function.

Botero is a figurative painter, but not a realistic one. His pictures are geared to reality, but do not depict it. Everything in his pictures is voluminous: the banana, the light bulb, the palm tree, the animals and of course the men and women. Botero is not concerned to paint particular things, for example fat men or fat women, but rather to use transformation or deformation as means of transforming reality into art. His creative longing, his aesthetic ideal, center on forms and volumes, a style that allows him to give expression to these visions. Botero, who like almost no other contemporary artist has studied the art of every period in museums, likes to point out that deformation in art has a long tradition. Giotto, Raphael, El Greco, Rubens and Picasso all deformed things and reality, in order to formulate something else in the process. The early Giotto, in whose time central perspective in painting had not yet been discovered, sought plasticity, the tangible form, in order to suggest three-dimensionality on a flat surface. Rubens in turn used the sensuousness of the flesh to introduce the ecstasy of faith into his pictures, in a quite different way from the mystical El Greco, who with his elongated, twisted, upwards-striving figures gave expression to a very personal religiosity as ecstatic as it was profoundly Spanish. And as for Alberto Giacometti's ascetic, "thin" figures, to mention just one 20th-century artist, the links with existentialism have been pointed out more than once.

The constant and comprehensive exaggeration and its uninterrupted repetition within a total artistic œuvre – as is the case with the above-mentioned artists, but also with Botero – makes deformation the rule and transforms it into a style. Deformation without a superordinate purpose and just for its own sake is either monstrous or caricature. Neither is true of Botero. On the contrary, his deformation always springs from the desire to enhance the sensuous quality of his pictures.

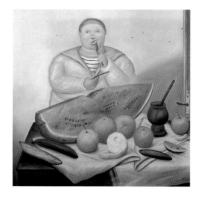

Boy Eating Melon, 1972
Oil on canvas, 164 x 171 cm
Private collection

OPPPOSITE:
*Self-Portrait on the Day of
First Communion,* 1970
Oil on canvas, 109 x 94 cm
Private collection

"It is important to recognize from whence the pleasure in beholding a painting derives. For me, it is joie de vivre combined with the sensuousness of the forms. That is why I have a problem creating sensuousness through form."
FERNANDO BOTERO

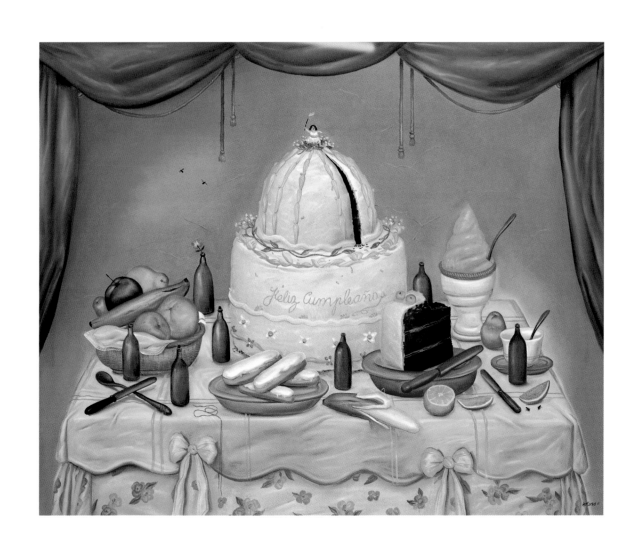

Bon Anniversaire, 1971
Oil on canvas, 155 x 190 cm
Private collection

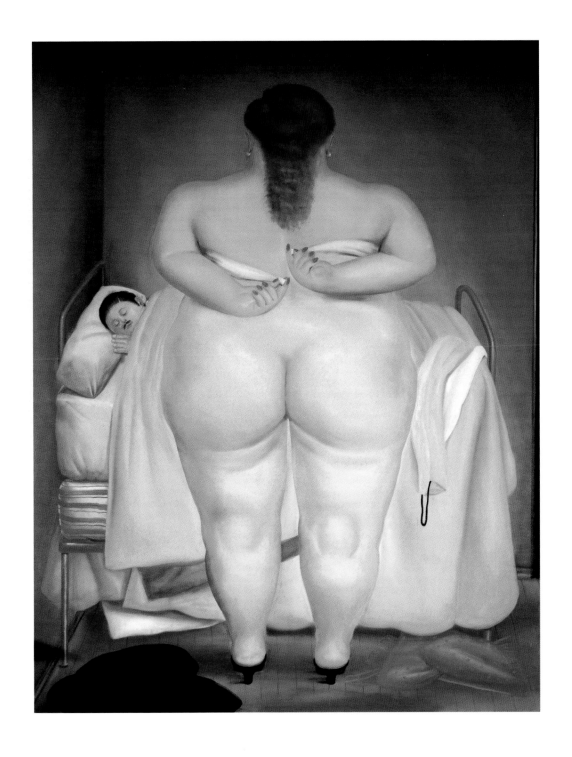

Woman Putting on her Brassiere, 1976
Oil on canvas, 247 x 195 cm
Private collection

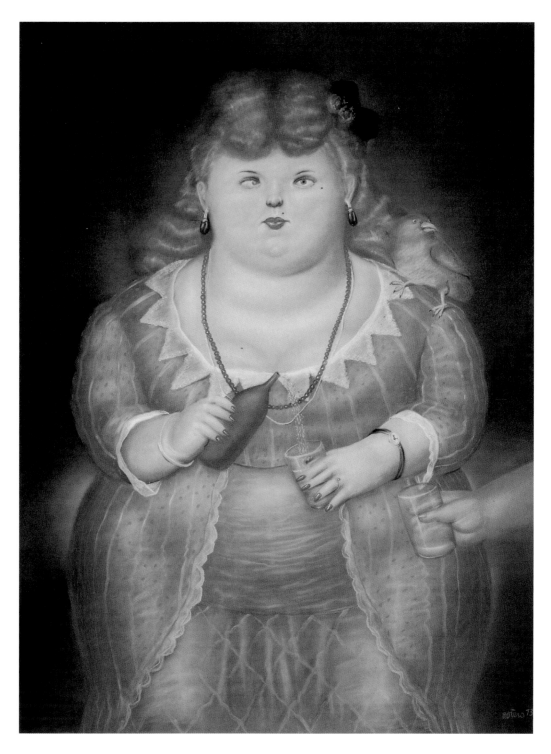

Woman with Parrot, 1973
Pastel on canvas, 161 x 121 cm
Private collection

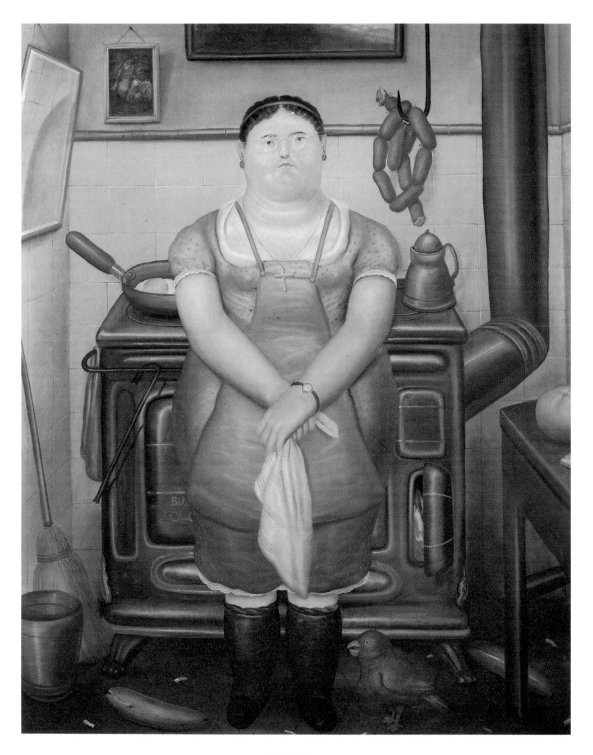

The Maid, 1974
Oil on canvas, 194 x 154 cm
Private collection

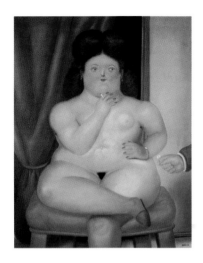

Seated Woman, 1976
Oil on canvas, 193 x 152 cm
Private collection

The Morning Toilet, 1971
Oil on canvas, 234 x 178 cm
Collection Aberbach Fine Art, New York

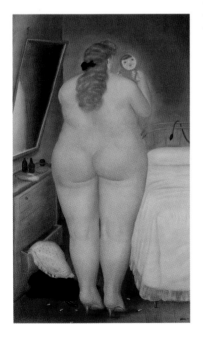

The voluminous corresponds to a formal predilection for the plastic values of classical art. As early as his time in Florence, Botero discovered that it was the sensuous presence of the early Italian masters that appealed to him, and he recognized that this affirmative Latin art, which with its emphatically formal elements lauded not only the glory of God but also of life, accorded most both with his visions and his artistic ideas. Formal opulence has a connotation that Botero deploys quite deliberately. Some artists make their problems with the world or the afflictions of life into the content of their works; the revered masters of the Quattrocento were not among them, and nor is Botero. On the contrary, whatever theme he takes up, his eccentrically expansive style robs it of harshness, viciousness, extremism. The *Houses* are no longer shocking, the bull-fight is stripped of its cruelty, the lady with the red-varnished fingernails ceases to be ridiculous and even love is no longer erotic. His exaggerated volumes are precisely the magic wand with which he transforms life and the world and transports them into a floating unreality. Paradoxical as it may sound, Botero's voluminous world comes across as balloon-like in its lightness.

While international art critics managed to link Giacometti's style with existentialism and thus were able to interpret him as an expression of the times, they have not yet discovered any legitimation for Botero's compositional principle. This circumstance too has isolated his work from the mainstream art currents of his age. Might this have something to do with an unsensuous, body-hostile reserve on the part of Anglo-American critics, as the Peruvian writer Mario Vargas Llosa once suggested? Is life-affirmation superficial, is only suffering really profound? Botero's work unfolds on the brink of this abyss, but never plunges into it. It is precisely this deliberately deployed, precisely observed artistic attitude, with its foundations in art history, which we call style, and which distinguishes Botero from the so-called Naive painters.

When he began painting in Colombia, his early essays pursued an international modernist style. Only when he started studying classical painting did he discover a style that so intensely corresponds with the soul of his continent. This was not a diversion, but in fact the precondition for the fact that this work can be taken seriously in the context of painting.

Is "thin" synonymous with "cosmopolitan" and "fat" with "provincial"? The fact is that in vernacular Latin America, "fat" is associated with positive qualities such as health, affluence, joie de vivre. Fat people are associated with good moods, sensuous pleasures and good-naturedness. Certainly Botero plays with the cliché of a continent of festivals and color, of the siesta and of good food. And accordingly the reaction of beholders of his works is mostly cheerful and relaxed.

But there are also more profound correspondences with the "expansive," correspondences that Botero with his overflowing volumes has possibly taken up unconsciously. For a people whose spirit feeds on myths and legends, which loves symbols and allegories, also possesses the creative qualities of exaggeration, extravagance and excess. Austerity is out of place here; what is wanted is the luxuriant, the splendid, the complicated. Colonial America is rooted in the Baroque, but this style, imported from Europe during the age of Absolutism, developed in the New World into a veritable jungle. In the churches of Latin America, in the splendor of their altars, in their crafts, and in their paintings, the opulent sensuousness of the Baroque broke free of its chains: "everything in excess" was the motto.

Admittedly ambivalences too can be discovered in Botero's luxuriant world of steaming pots, juicy fruits and well-stocked larders. The Italian writer Alberto

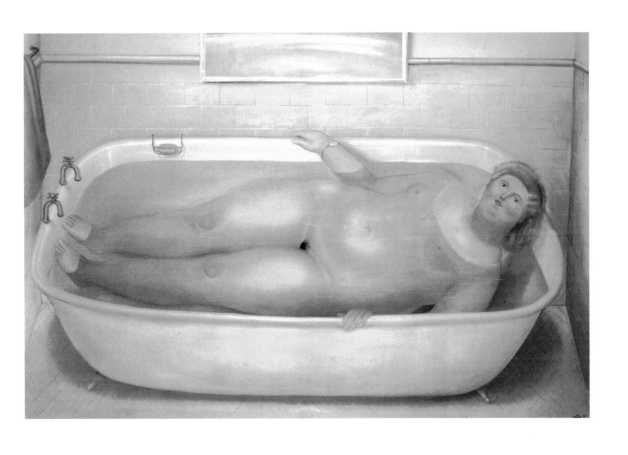

Homage to Bonnard, 1975
Oil on canvas, 183 x 274 cm
Private collection

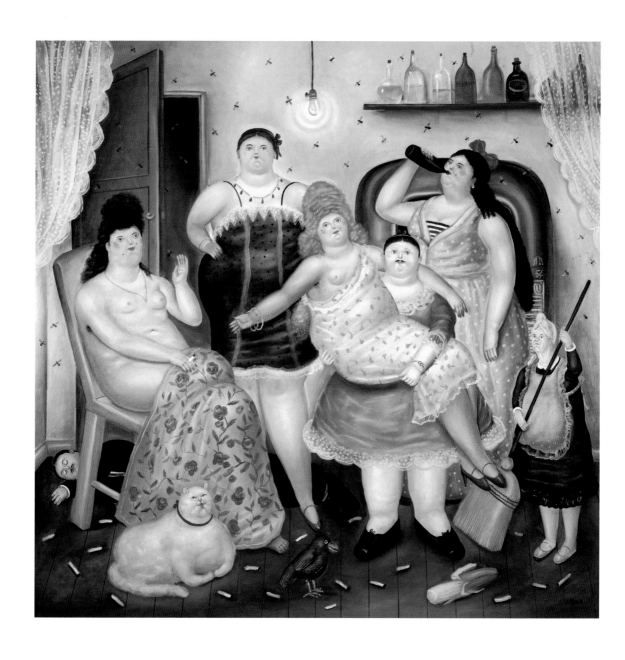

The House of Mariduque, 1970
Oil on canvas, 180 x 186 cm
Private collection

Archangel, 1986
Oil on canvas, 196 x 136 cm
Private collection

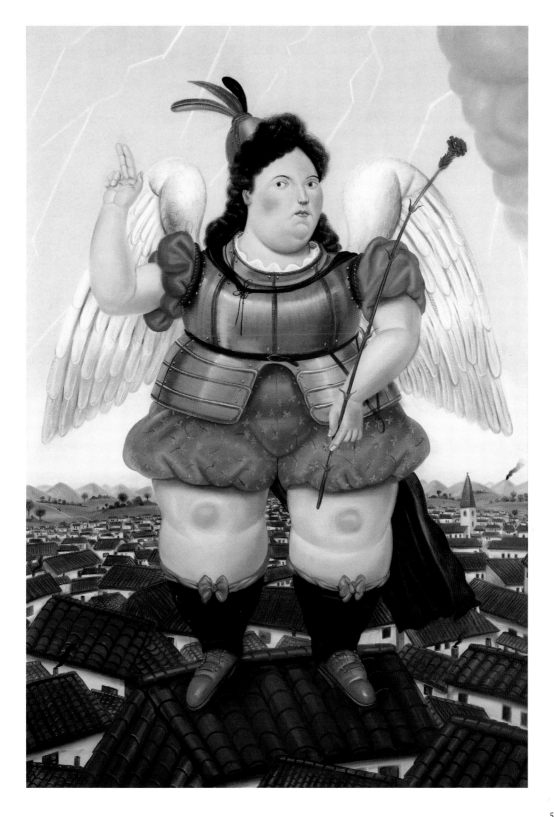

Moravia, for example, saw in his heavy-limbed, corpulent figures "not only an aesthetic, but also and especially a psychological factor." It conveyed, he said, the dark and basically tragic sensation that in this bloated world a very particular suffering was being expressed, at the same time paralyzed and painless. The revolution of Rivera and Orozco, the declaration of war on poverty and injustice, on dictatorship and violence – Moravia sees all this "tamed to death" in Botero's world of images. A nightmare: life is peaceful now, but lethargic. This world, according to Moravia, had become "enormously fat and complacent." And this disquiet, in the Italian's view, was the origin of, and reason for, the artist's ponderous view of the world.

Botero is a polite master, indeed a gentleman among the artists of the 20th century. If indeed he does feel such disquiet, he is extremely discreet in the way he expresses it. On the contrary, he never tires of explaining that his work is above all the result of a great passion for shapes and colors, for sculptural values and volumes – in other words results precisely from an aesthetic disquiet and no other. All he (the man from the provinces) ever wanted to paint was "beautiful" pictures. Beauty for him meant, first of all, formal perfection as far as composition, color and craft were concerned. Not at all provincial, by contrast, was his analysis in the sense of Leon Battista Alberti: beauty comes about when all parts are in harmony, when the composition is entirely balanced by symmetry. The decisive factor in his pictures, he said, was not a particular statement, but the compositional lines, the verticals, the horizontals, the diagonals and the free line added at the end in the form of a branch, a string of pearls or a snake. The composition, though, proceeded from the calm and solid form. For this reason too he always rejects any reference to the Baroque, which, as he says, is centrifugal, while his work is centripetal, the forces are silent, and strive towards the center. His work "is not Baroque, but the expression of abundance".

Immaculacyo is for him a major concern in connection with the idea of beauty. Thus there are in his pictures no shadows, because they "dirty" the colors. These pictures always shine forth in a kind of early-morning light, where the shadows are least. The light does not spring from an external source. Things shine by virtue of their own color. While in general in painting volumes are suggested by hatching and shading, Botero dispenses with these methods too, and for the same reason. Like the light, plasticity in his pictures is created by means of color. The goal is always "to create surfaces in which the color can express itself afterwards as profitably as possible." The goal is the perfect, even colour surface.

Botero has always admired stillness in art; it always gives him a feeling of the infinite, most especially in Egyptian sculpture. Although his pictures are in the highest degree narrative, the movement in them comes across as frozen. This quality results above all from the monumentality of the figures and their relationship with the space they occupy, for which they appear much too large to be able to move. Thus not only is their skin stretched over their ample bodies, but their own confining walls seem to be stretched tightly around them.

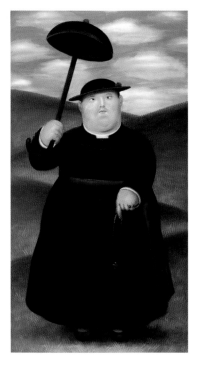

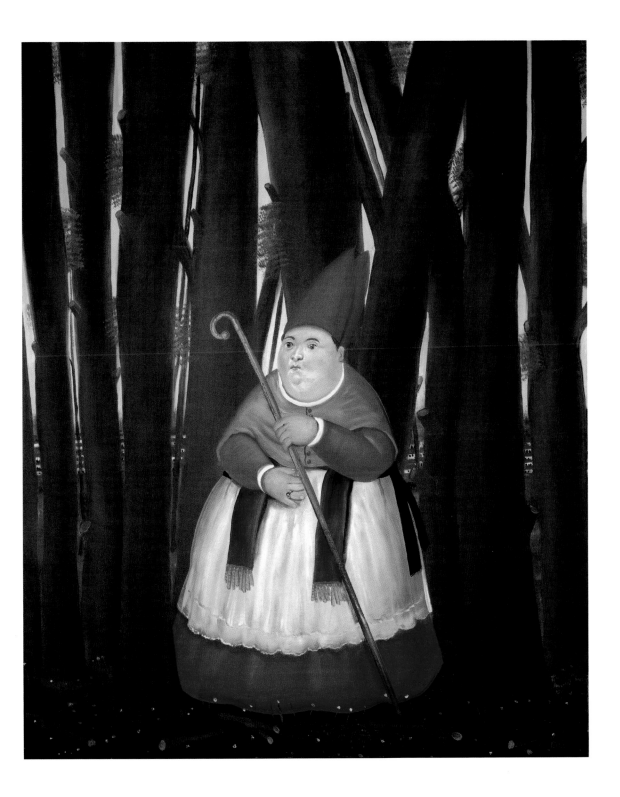

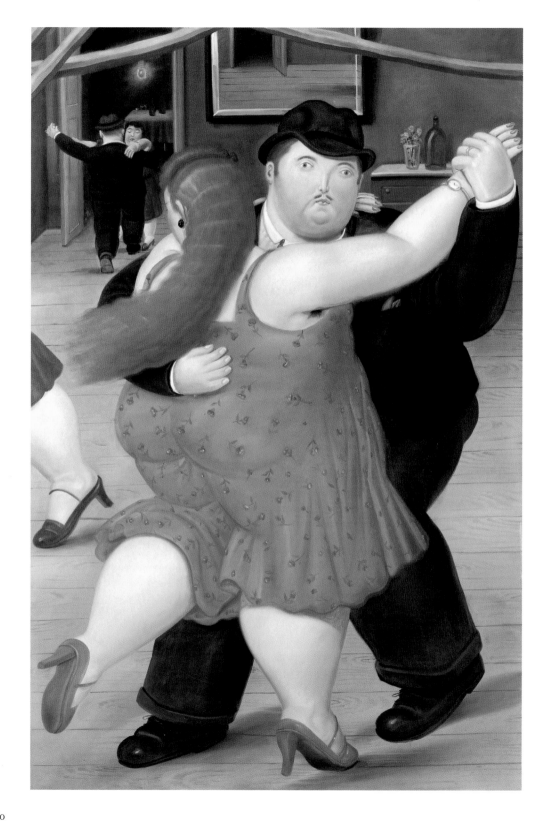

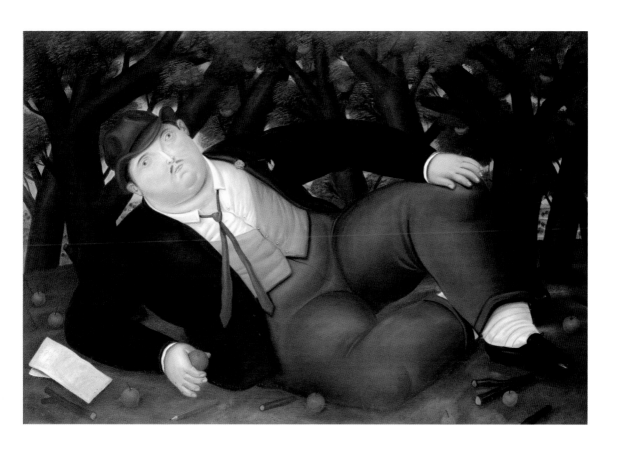

Dancers, 1987
Oil on canvas, 195 x 131 cm
Private collection

The Poet, 1987
Oil on canvas, 140 x 208 cm
Private collection

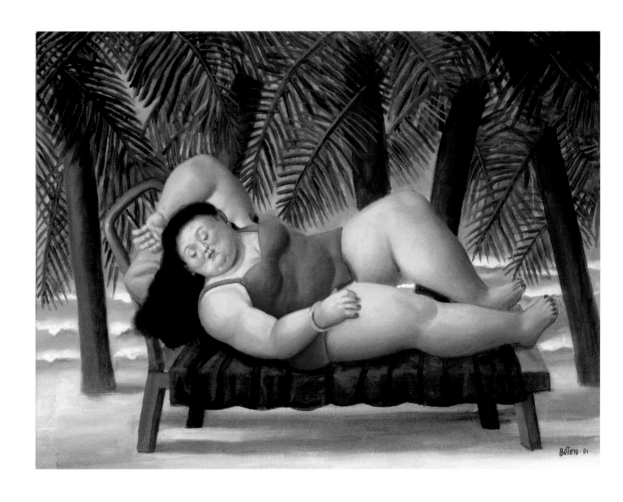

Bather on the Beach, 2001
Oil on canvas, 37 x 49 cm
Private collection

Dancer at the Pole, 2001
Oil on canvas, 164 x 116 cm
Private collection

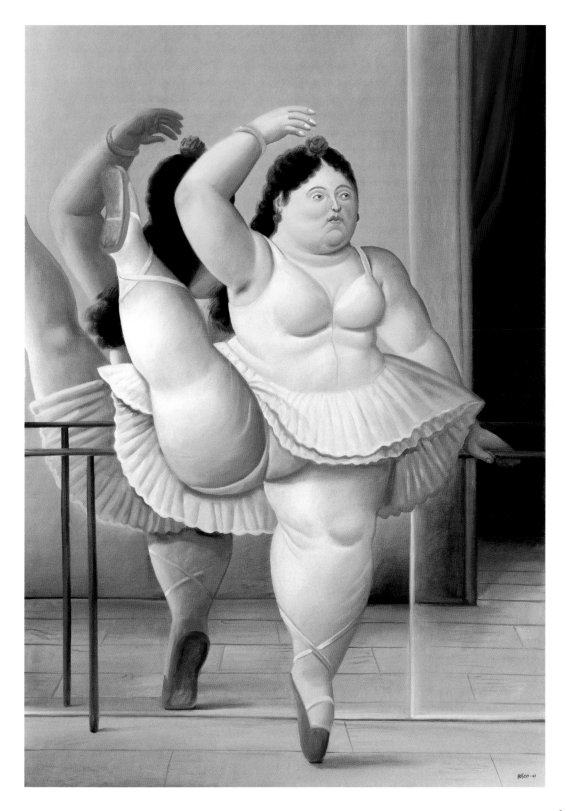

63

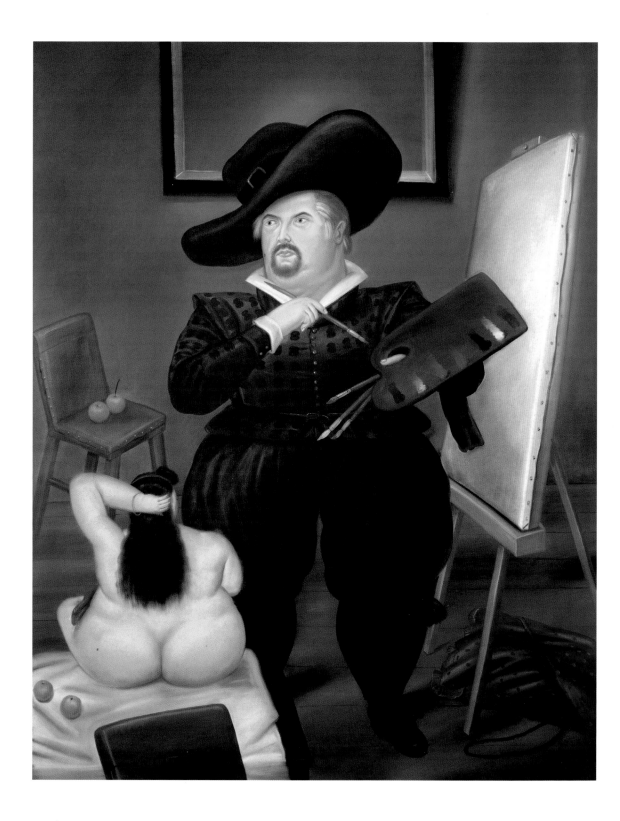

The Artist's Studio
Paris – New York – Monte Carlo – Pietrasanta

Fernando Botero rented a flat in Paris as early as 1972, and the following year it became his home base. Although not long afterwards he found a pied-à-terre in busy New York once more, Paris, the city of intellectuals, the city of the Louvre and the capital city of all Latin American artists in Europe, has remained to this day the place where Botero most likes to paint. His two-story studio in the rue de Dragon, just a few minutes from his flat, is quietly situated in the back part of a building; the atmosphere of peace and seclusion in the midst of the hustle and bustle of Saint Germain is characterized by soft, filtered light.

Botero works every day, and he does this because for him, there is no greater pleasure than to paint. He is no bohemian, but a painter of canonized forms, in society as in his painting. In a precise fashion thoroughly out of tune with the times, he has mastered the techniques of oil painting, grounding and varnishing. Alongside Berenson's book on Italian Renaissance painting, which was and is fundamental to his formal pictorial analysis, Botero also owes his stupendous practical knowledge of painting techniques to the 1921 standard work on painting materials and their use by the German restorer Max Doerner. He also works in pastel with great sophistication. This technique has probably not been used in the classical manner since the 18th century. Unlike Edgar Degas or Henri de Toulouse-Lautrec, who used their pastel chalks more like pencils, Botero designs his pastels with dense, deep color surfaces.

Not only does Botero work every day, but he does so in a manner that is just as concentrated as it is relaxed, because he does not believe for one minute in an art "with its roots in pain." And just as every day in his life follows a set order, the same is true of the rhythm of his year: spring is spent in Paris, summer in Pietrasanta, then Paris once more, before he leaves to spend the late autumn and winter in New York, before returning to Europe to await the coming of spring in Monte Carlo. This Colombian is a relaxed globetrotter: this can be done only by someone who carries the globe within himself, who is at home everywhere and nowhere – only with himself. During all these years, Botero has remained an émigré, outwardly naturalized, but basically nothing other than the man from Medellín who wanted to be a painter and whose wish was fulfilled. For his singular œuvre, which seeks to be nothing other than the expression of his Colombian identity, this is doubtless a basic precondition. Everywhere, there are well-equipped studios waiting for him. Botero doesn't need large rooms, only

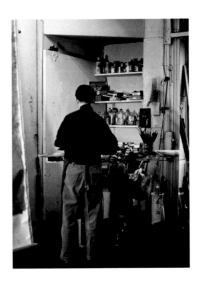

Botero in his New York studio, 1963

OPPOSITE:
Self-Portrait in the Costume of Velázquez, 1986
Oil on canvas, 218 x 185 cm
Private collection

65

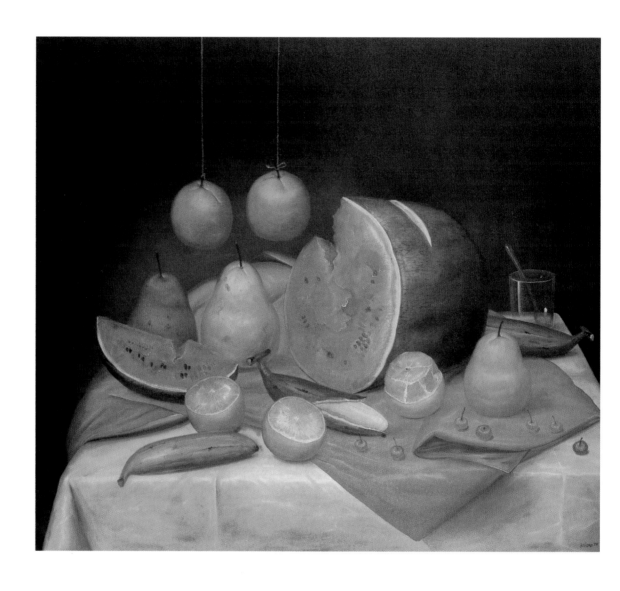

Still-Life with Watermelon, 1974
Oil on canvas, 166 x 168 cm
Collection of Mrs. Susan Lloyd

The Collector, 1974
Oil on canvas, 91 x 79 cm
Collection of R. Lerner, Madrid

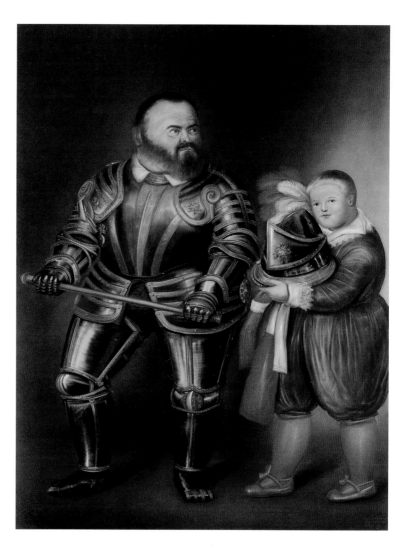

Alof de Vignancourt (after Caravaggio), 1974
Oil on canvas, 254 x 190.5 cm
Mr. & Mrs. Carlos Haime

good light. He does not use easels, because he paints on loose canvases, which he fastens to the wall, using a system he has worked out for himself, allowing him to roll and unroll the canvas upwards or downwards, which in turn allows him to keep the part he is painting at eye level. He thus works without stretchers, which means the size of the picture need not be fixed until he has finished it.

The most important work in connection with the picture is the concept: the ideas must be clear before he starts. Then his basic structure is recognizable within a few hours: the composition and colors are laid down. Weeks later, when the paint is dry, he investigates other possibilities, which, following the first explosive act, he calls the reflective phase. In the process he adjusts the composition for as long as it takes to get the balance right. Although Botero is a magnificent draftsman, his pictures are chiefly determined by their color fields. He starts applying paint in the centre of the motif and proceeds as far as the next colour field. Color is fundamental, says Botero, "because it gives light to painting. The picture achieves perfection only when the color question has been solved. You think about the composition, but in reality it is the color that determines the

picture. When every element has found its place, there is peace." Botero always works on a number of pictures at the same time, a practice that has evolved owing to his elaborate technique of using different layers of paint. Occasionally there are pictures that "rest" for a long time, before being brought out again.

His palette has changed over the years: from the consistently strong colors of his early days, via the earthy hues of the 1960s, to the transparent, pale colors of later years. All in all, a reduced colour range is characteristic of Botero: he always works with four to seven colors: cobalt blue, ocher, crimson and green, plus black and white.

The painting process itself follows the classical tradition, to the extent that Botero applies a number of layers of paint. Having grounded the canvas salmon-pink, he first sketches the major shapes of the picture in white chalk. The salmon hue, which incidentally was also used by Giorgione and Titian for their grounds, gives Botero's oil paintings the pastel appearance that has been particularly characteristic of his works from the late 1960s. The artist is as economical with his brushes as he is with his range of colors: one fine brush, and one that is broader and flatter – that's all he requires.

Without a doubt Botero's yearning for perfect craftsmanship is a concern that is linked to his Latin American origins. It springs from that innocent idea held by his fellow South Americans: namely that the beauty of a work of art is bound up with the perfection of its creation and its porcelain-like finish. Hardly any other artist has reflected so consciously and clearly on his own work than Botero – possibly precisely because it was produced "in the diaspora." He is accordingly clear about what he is doing. Thus the criticism, loudly voiced by sections of the "cosmopolitan avant-garde" that what he practises is a pedantic old-masterly manner coupled with folk-art themes, no longer bothers him. One of his most important goals lay in achieving a congruence between himself and the work.

Botero is not a man of haste or emotional outburst, but of thoughtful reflection – in total contrast to the "Latino" stereotype. He sees his work grounded equally in the history of art and in his own identity, and this provides him with the tranquillity that has been confirmed by his success over the years: "I realized with satisfaction that by following myself, I was also behaving properly towards my country. My painting ability means that it's up to me to express things, and not to copy the Americans or the French in order to paint pseudo-American or pseudo-French pictures. I have to paint Colombian pictures. And the surprising thing about it now is that by painting decidedly Colombian pictures, I impress the Germans, the French, the Japanese." Among the examples of this acceptance, which comes from the public and not from museums, are the exhibitions of sculptures in such places as the Piazza della Signoria in Florence, the Champs-Elysées in Paris or Fifth Avenue in New York. None of these exhibitions was suggested by a museum director or art critic: they were held because the cities themselves wanted them.

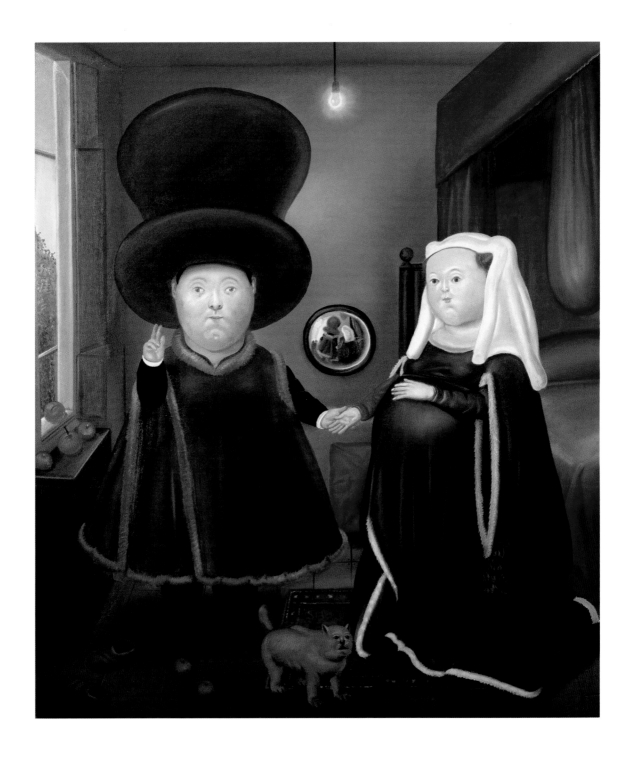

The Arnolfini Marriage (after van Eyck), 1978
Oil on canvas, 135 x 118 cm
Private collection

Mademoiselle Rivière (after Ingres), 2001
Oil on canvas, 177 x 131 cm
Private collection

ABOVE AND OPPOSITE:
Federico da Montefeltro and Battista Sforza (after Piero della Francesca), 1998
Oil on canvas, 204 x 177 cm
Private collection

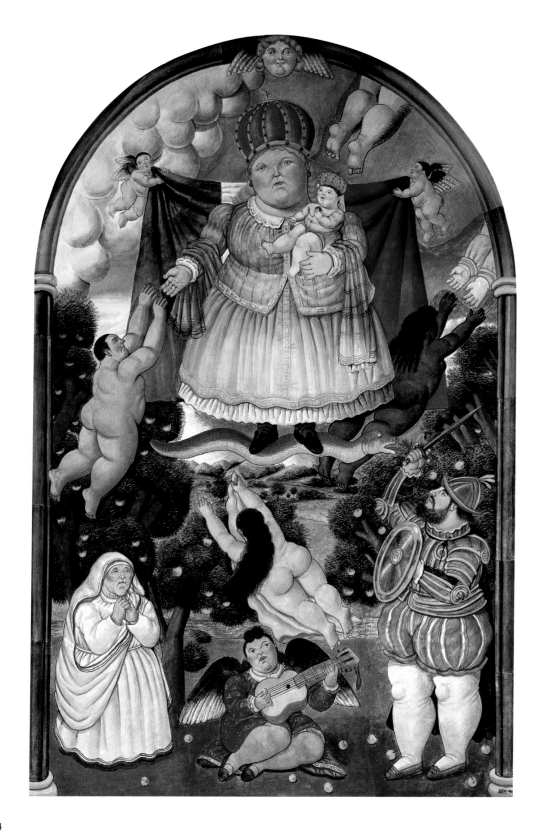

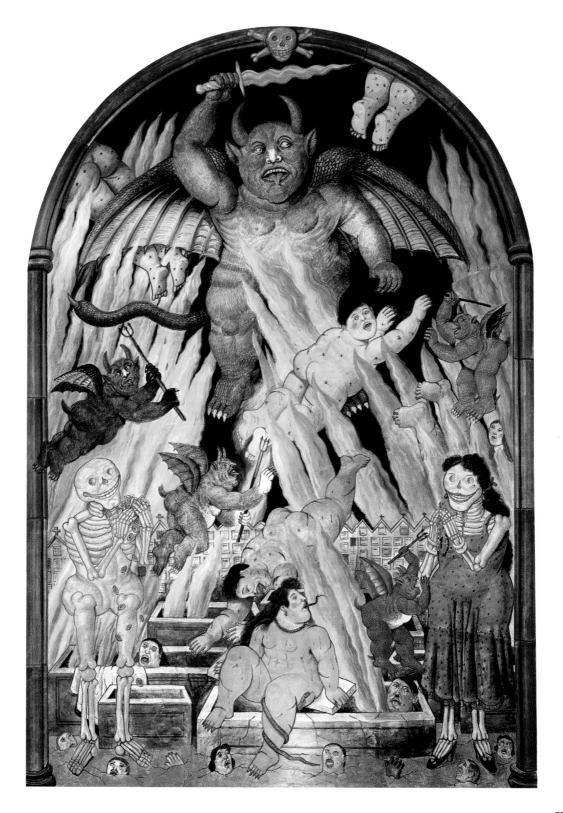

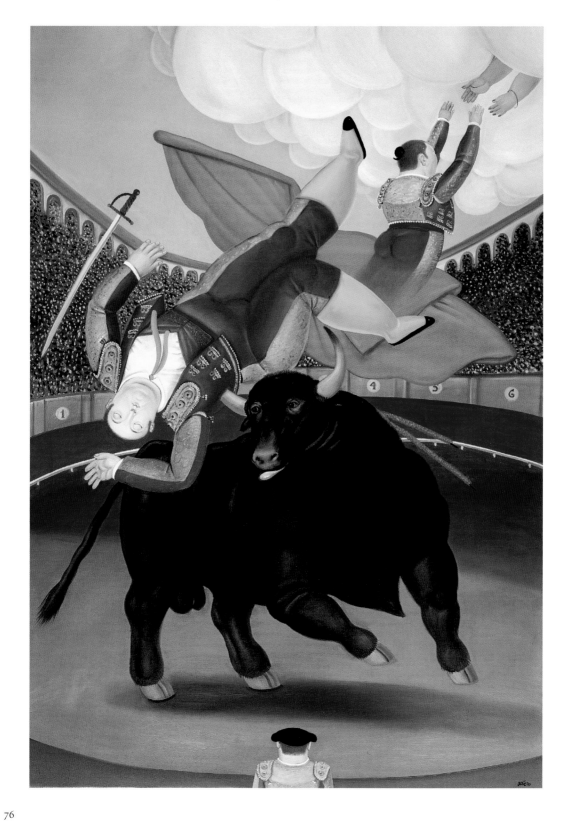

Latin America as Theme

Botero's development as an artist was determined at an early stage by the search for a means of expressing his own identity, as well as by a certain "aesthetic unrest," as he calls it. He found this expression chiefly by self-exploration and through the will to be honest to himself and thus to his roots. For the implementation of his aesthetic ideas, by contrast, he oriented himself towards the great traditions of European art. The content and form of his art are an individual, highly personal expression, which, moreover, was recognized at an early stage to be the hallmark of the South American within him – both by his compatriots and by people from other parts of the world.

Among the visual artists of Latin America, Botero can in this respect be compared only to Diego Rivera, who likewise first worked in Madrid and Paris, until one day he was urged fairly roughly by Picasso to return to Mexico, in order to paint in a "Mexican" manner instead of imitating Cubism and other styles of the modern European movement. In Rivera's day, the situation was different to the extent that in 1920s Mexico the impulses of the 1910 Revolution had also exerted an influence on the cultural climate. Mexican society was in a state of upheaval, and artists saw in this a task which transcended their individual ideas of art.

Although Rivera had been able, together with like-minded artists, to found something like a "Mexican school" based on a utopian design along with a return to the roots of ancient America, such ideals had long evaporated when Botero came on to the scene. In the nineteen-fifties, there was no cultural center of supra-regional significance in Latin America to which Botero could have introduced his artistic ideas. And so there was for him basically no alternative to life in the great art centers of the world. This is why his work was created far away from home, and in self-chosen, yet necessary solitude. Here the painter consciously set himself up in opposition to international trends in art: and it is this that his first biographer, Germán Arciniegas, sees as Botero's truly revolutionary act. Because the pictures themselves are not revolutionary – and never tried to be.

On the contrary, Botero's rebellion is directed against everything that surrounds him but does not belong to him. Thus he deliberately responded to "cosmopolitan arrogance" with "provincial ingredients" (Arciniegas). And indeed Botero's figurative, seemingly naive paintings, many of them overloaded with a great deal of pictorial material, at first scandalized the New York scene and its art

The Rape of Europa, 2001
Oil on canvas, 53 x 44 cm
Private collection

OPPOSITE:
The Death of Luis Chaleta, 1984
Oil on canvas, 175 x 121 cm
Private collection

Europe and America, the Old World and the New – it is between these two geographical regions and their respective cultures that Botero's pictures move. Thus the artist takes up a very specifically Latin American tradition, in order to formulate a wonderful, timeless image of his world. The bull fight, imported from Spain centuries ago, belongs here just as much as the *Fiesta* along with the eroticism of the dance and the sentimental music ensembles.

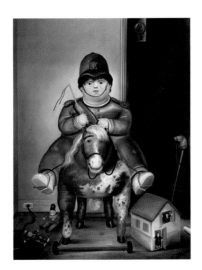

Pedrito on Wooden Horse, 1974
Oil on canvas, 194 x 150 cm
Museo Botero, Medellín

PAGE 80:
Death of Pablo Escobar, 1999
Oil on canvas, 45.7 x 34.3 cm
Private collection

PAGE 81:
Carbomb, 1999
Oil on canvas, 112 x 82 cm
Private collection

critics in the 1960s, while soon going on to appeal the public with their exotic echoes, their humour, and their occasional irony. One of the most important New York art-dealers in the nineteen-sixties, Jean Aberbach, was probably the first to recognize that particularly the "popular" elements in the Colombian's work had highly cultured roots.

In 1986 Botero painted the *Self-Portrait in the Costume of Velázquez* (ill. p. 64). Only when seeing this picture side-by-side with the latter's own self-portrait in his major work *Las Meninas* will the beholder notice with surprise that the composition is completely different: the placing of the canvas and of the model, the pictorial space and indeed even the costume all deviate from the original; even the huge, not to say dominant hat is absent from Velázquez's picture. The only thing common to both paintings is the attitude of the arms and hands, the way the brush and palette are held.

Botero has, then, created a new picture, although the beholder does not notice this at first, directly understanding the allusion instead. Velázquez, the court painter, who gave Habsburg Spain a final, incomparable memorial, is an important role model for the South American artist. Or does the latter even see himself, as we have noted in the case of the *Dinner with Piero and Ingres* (ill. p. 41), as a like-minded artist? Velázquez is the painter who like no other captured the essence of the Spanish, in that he created both the forms and the manner of presentation that accorded with the national spirit. He belongs "like Dürer in Germany or Rembrandt in Holland to the truly national painters, in whom a nation can recognize its very own self and its better self" (Carl Justi). And indeed, our ideas of the golden century of Spain have been stamped by Velázquez's pictures, even though he hardly painted anything apart from the small circle of people at the court of Philip IV. But it is precisely to this concentration on a closed world and its symbolization of a whole society that we owe the truthfulness of Velázquez's art.

In his self-portrait, the painter Fernando Botero is standing opposite a seated female model. For the beholder, it will be a rear-view nude like Velázquez's famous Venus in the London National Gallery. Botero's model, however, ample and robust as she is, with long black hair, red hair-ribbon and varnished fingernails, accords not with the ideal of beauty at the Spanish court, but rather with American female prototypes he had invented himself, such as we are familiar with from Botero's pictures. The relationship of the size of the respective figures within the picture, which is dominated by the oversize figure of the artist, suggests a Botero representing himself as his country's national painter, indeed his continent's continental painter, as the "inventor of truths" about Latin America – altogether in the spirit of the great Spaniard whose secrets he had penetrated in countless paraphrases and copies.

In his Paris studio there hangs to this day a large, very freely painted *Infanta* after Velázquez in an extravagantly carved frame, a masterpiece of 20th-century reinterpretation of the well-known subject. It is then not only the "lofty aloofness" that Botero admires in Velázquez, but also his unique function as Spain's painter. And just as the Spaniards can admire the major works of their greatest painter in the Prado, Botero too has donated two great collections of his works to his own country, housed in museums in Medellín and Bogotá, so that his pictures might be accessible to the people there. Botero has always defined his responsibility as an artist as a responsibility towards the people of his homeland. He wanted to create things that mean something to them, that create a sense of identity. Thus he has always painted a Colombia such as he would like to see, an

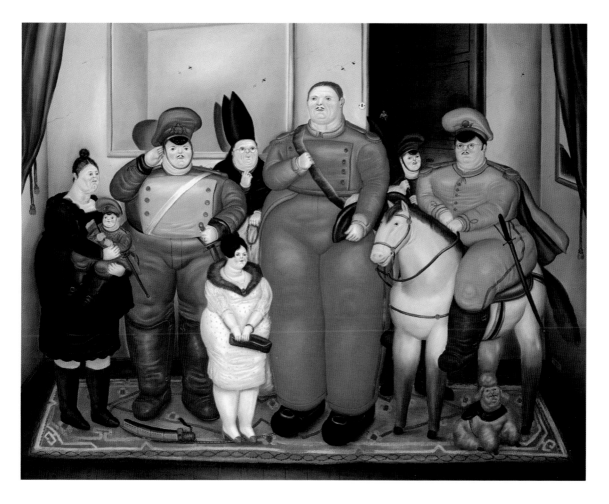

Official Portrait of the Military Junta, 1971
Oil on canvas, 171 x 219 cm
Private collection

The picture *Official Portrait of the Military Junta* looks
familiar at first sight, recalling Goya's famous *Family of
Charles IV* comes into one's head. The figures are arranged
differently, but the group picture of standing men and
women, presented as a ruling family, clearly has its roots in
this work. Neither Botero nor the Spaniard of the revolution-
ary period actually accuse these rulers; their pictures are
devoid of bitterness and sarcasm, but the protagonists of
power in both works are in reality weak figures, devoid
of will, depicted as toys – one of the generals is even in
the arms of his nanny, who is humoring him with a little
Colombian tricolor. In Goya's picture, this position is
occupied by one of the royal children.

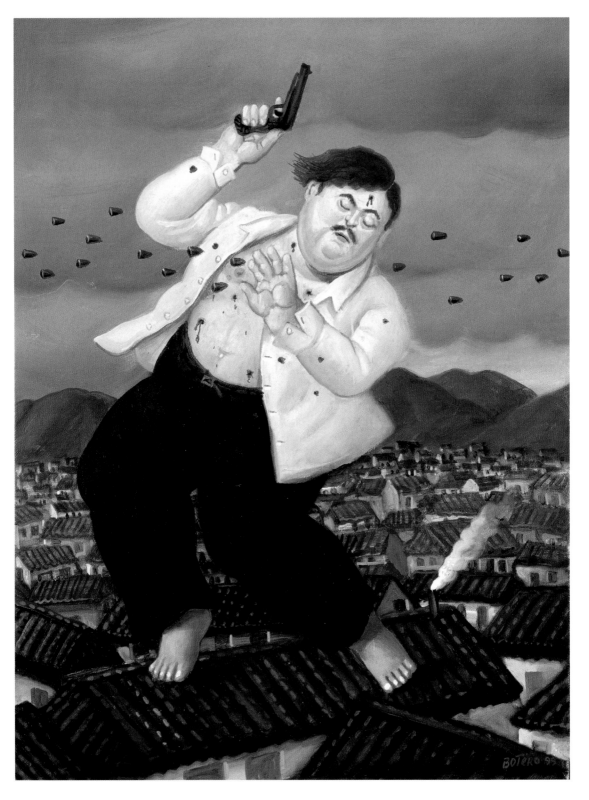

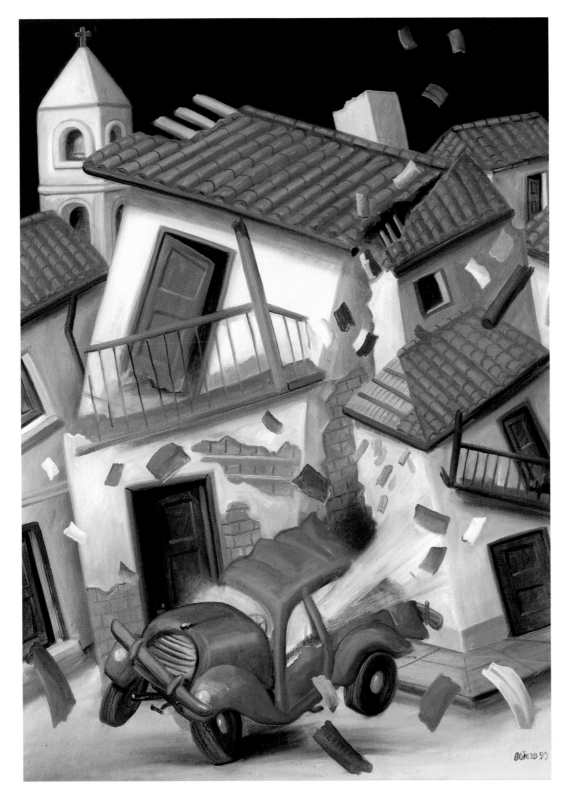

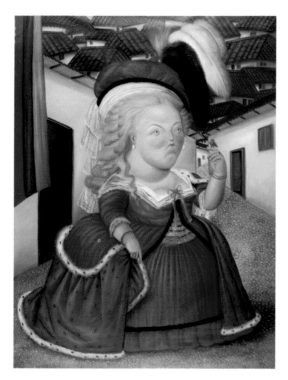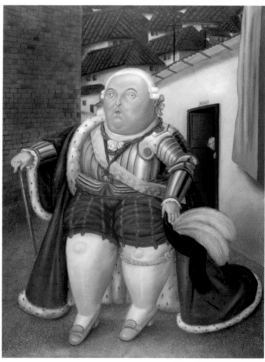

Louis XVI and Marie Antoinette Visiting
Medellín, Colombia, 1990
Oil on canvas, diptych,
each 208 x 272 cm
Private collection

imaginary Colombia, making visible in his pictures what is present though hidden in this country, in its culture and among its people.

Botero paints everything the classical painters also painted. One of their traditional remits for a long time was the portrait of the ruler, something that had lost its importance by the 20th century. Botero however took up this theme a number of times, even though the subjects he presented to his amazed public were always anonymous, unidentifiable rulers. A particularly fine example is the great diptych *The President and the First Lady*, painted in 1989 (ill. p. 83), both on horseback as in Velázquez's *Isabella of Bourbon and Philip IV* in the great central hall of the Prado. The heroic feel to these ruler portraits, which finds its expression not only in the figures and their costly garments, but also in the landscape in the background and the noble horses, is however not adopted by Botero. The elected equestrian president, in a dark jacket and gray trousers, with his middle-class consort in her evening-gown, sit like bloated dolls on their clumsy horses. The background is formed by huge banana trees: an allusion to so-called banana republics? Botero leaves the beholder to answer this question. However the banana is not only at the heart of Colombia's economy, but also of its flora. Between the much too thick trunks of the banana plants one can espy here and there, painted very small, but finely, another symbol of the country, the cordillera. The pictures are timeless, their subjects are nameless prototypes, but they convey an impression as amusing as it is magical, of those South American presidents who, since the 19th century – on horseback – have publicly displayed their provincial solemnity, right up to the present day. It is precisely the concealed reference to Velázquez that constitutes the charm of these pictures, in which we feel reminded of the American copies of European artworks of the colonial period with their eccentric deviations from the imported originals.

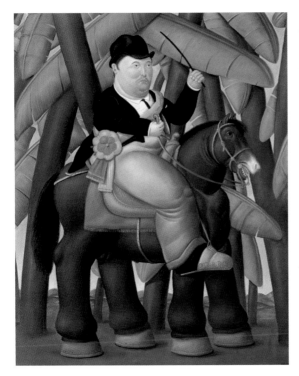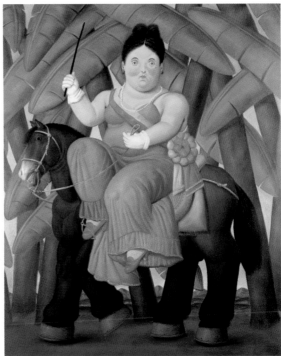

Another of Botero's "ruler pictures" is the 1971 *Official Portrait of the Military Junta* (ill. p. 79), which is similarly ambivalent. What military junta is it supposed to be? There are said to have been ten in Latin America at that particular time, so that the subject was obvious enough. Did Botero paint this junta in order to immortalize it, to make fun of it, to pillory it? He does not answer these questions, but explains how the picture came about: "If for example I start to paint a dictator, I have to be treat the colors carefully and lovingly – somehow it is an act of love. Painting turns hate into love. It is not like with Orozco, the Mexican painter, who created political pictures. There was hate in every one of his brushstrokes. In my case it is precisely the opposite. There is love in every brushstroke."

In no other motif does Botero's vocabulary of voluminous forms come across more aggressively than in the female nude; no other motif in his world of images stays longer in the memory than these massive figures with their overflowing hips and colossal thighs. As incidentally in the work of Rubens too, it is these which trigger the strongest feelings in those who behold them: either total admiration, or total rejection. Botero's female figures are heavy, and clumsy like everything he paints, and in spite of the voluptuousness of the flesh, they are remarkably unerotic: only on giving them a closer look does the beholder notice that their breasts are stunted and their pubic hair so sparse as to be barely visible. Nowhere is there the slightest hint of lasciviousness, desirability or passion. Instead, these are if anything shy, prudish and occasionally respectable and motherly characters who can provide their – mostly very much smaller – husbands with protection rather than erotic pleasure. When they remove their bra or let their hair down in the bath, the Italian writer Alberto Moravia would run away if he could. For, as he writes, these women "cannot enter into a relationship with

The President and the First Lady, 1989
Oil on canvas, diptych,
each 203 x 165 cm
Private collection

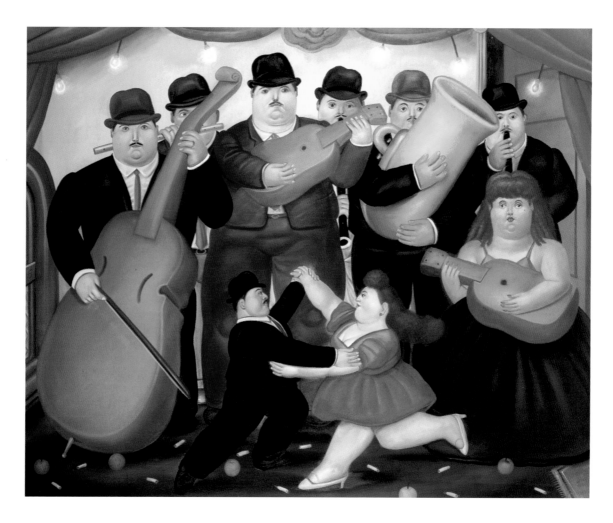

Ball in Colombia, 1980
Oil on canvas, 188 x 231 cm
Private collection

their partners, nor give themselves to them, or unite with them. And the partners, no less shapeless than they themselves, find themselves exposed to the same limitations. It is like a destiny that neither can escape. The men and women in Botero's shapeless world can at best like each other and maintain a weak, dreamy mutual fondness that knows no passion."

What in the other motifs is less striking comes across in the female nudes in total clarity: shapelessness is an additional burden, which documents not only the unfulfilled pleasures of the senses, but also the dark side of the remote Andean provinces. Botero admittedly would seek to put the brakes on such thoughts: no, he is interested in sculptural values, in the volume, in the color field; this obesity is an artistic, not a realistic, way of creating sensuousness. And indeed his women are shown at the moment of their "perfect maturity," time is suspended at this moment of "extreme vitality" (Mario Vargas Llosa) – and of extreme volume.

Even more sensuous than Botero's female nudes are his still lifes – a genre that traditionally has been preferred by painters for the pure pleasure in painting that it provides, and as a virtuoso demonstration of their skill. Here too he makes reference to everything that tradition can offer, from the kitchen still life

with onions, pumpkins, other vegetables and a pig's heads to the lovingly arranged floral still lifes. Among fruits, he prefers bananas, pineapples or watermelons, because these are the fruits of Colombia. Edouard Manet's *Déjeuner sur l'herbe*, which harks back to Giorgione, combines the group picture with the still life. In Botero's picture, these pictures have the modern name *Picnic*. Although he plays with a déjà-vu effect from art history here too, he creates a new kind of picture, of an attractive life with highly sophisticated culinary eroticism. Indeed Botero would seem to paint only on Sundays, when people are enjoying their leisure time in their best clothes and with their hair well combed. The world of work by contrast is seldom portrayed; at most we see an intellectual at his writing desk, a policeman catching a thief or seamstresses in their room (ill. p. 87). We look in vain in Botero's pictures for the factory worker, the day-laborer or the toiling Indian. As a result of the terror that has shaken Colombia in recent years, fear and violence have come to Botero's pictures. But in his altogether idyllic Sunday world, they are the exception.

Another classical painting theme, which Botero is one of the few 20th-century painters to have taken up, is the family picture, which he likes very much, because it has an attractive tradition in Western painting. Of course it also provides attractive material for the Latin American myth, in which the family is the elementary unit of society. The material is also suitable for formal adventures, always of concern to Botero, but more still for the poetic evocation of a society that in reality does not exist.

Memory can be deceptive, and so can works of art. Both tend to idealize reality. Botero paints the whole spectrum of the middle-class society of his continent: office workers, ladies, gentlemen, nuns, bishops, policemen, officers, old maids, girls giving sidelong glances, prostitutes, thieves or courting couples. His view is good-natured, benevolent, without tension and without suffering. Everything can be seen in these pictures, but frozen in a strange unreality, because their visual vocabulary dates from a different age. Melancholy and yearning are widespread in this world of memories, nostalgia and disappointed feelings. But that too is a dominant motif in South American art: in literature, in music and in the world of Botero's pictures.

South America is not a place to go looking for formalistic aesthetics. On the contrary, it is characterized by a decidedly communicative view of art, which prefers the message, the symbol and not least a recognizable picture. For this reason art is there, more than elsewhere, an attempt at a dialogue between artist and beholder, reader or listener. From the European or Anglo-American point of view, this can certainly be described as an obsolete rhetoric: but Fernando Botero is not bothered by that.

The Thief, 1980
Oil on canvas, 165 x 111 cm
Private collection

Cat on the Roof, 1978
Oil on canvas, 87 x 77 cm
Private collection

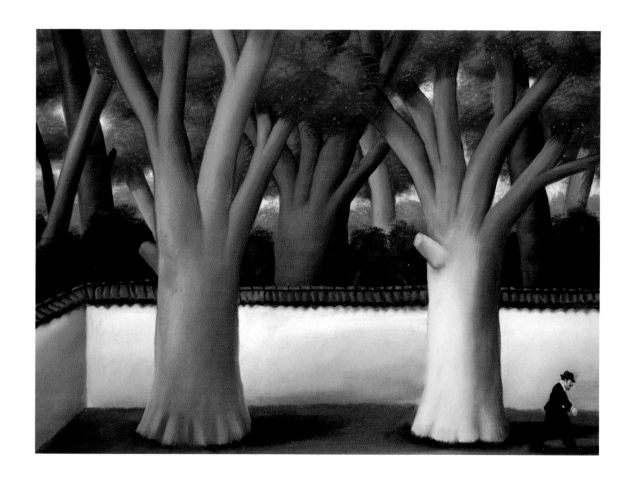

Man on the Street, 2001
Oil on canvas, 88.9 x 65.4 cm
Private collection

The Seamstresses, 2000
Oil on canvas, 205 x 143 cm
Private collection

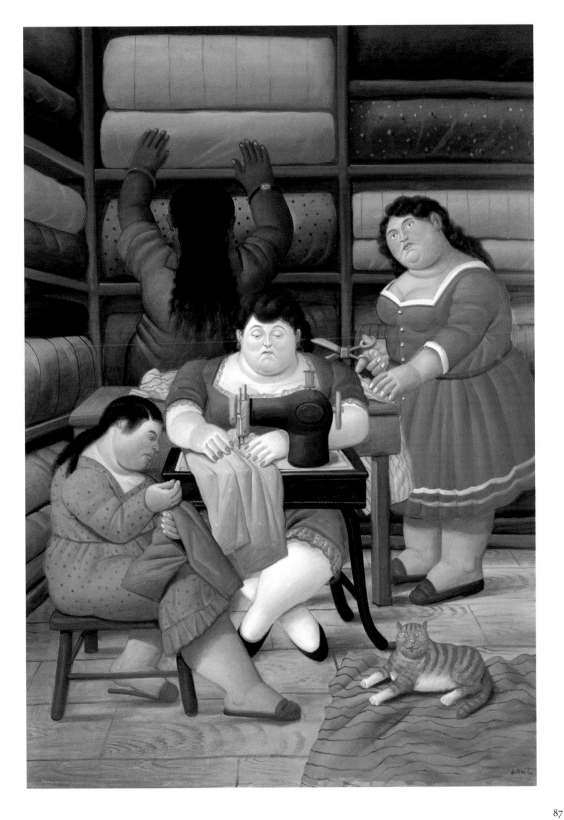

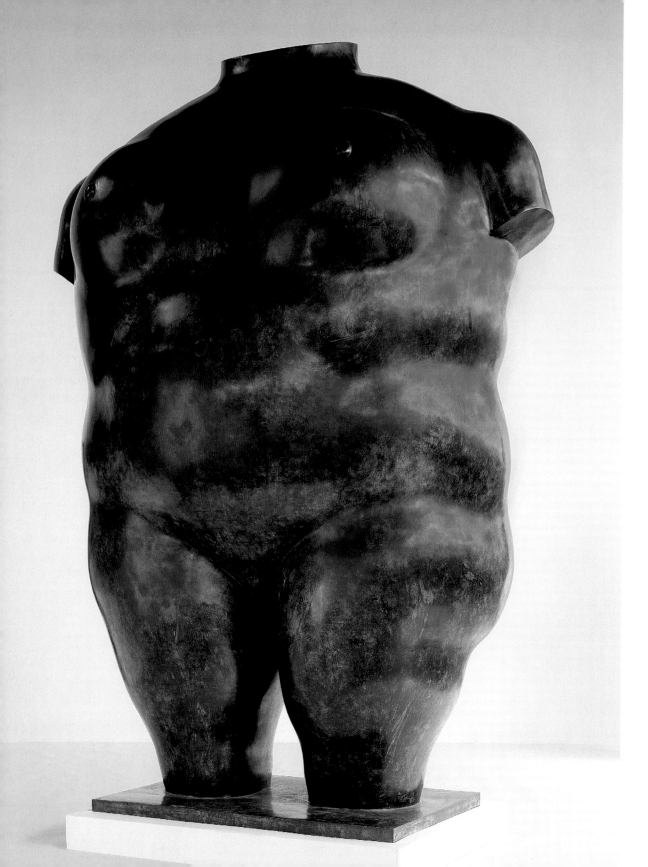

Fernando Botero the Sculptor

As long ago as 1963/64 Botero was already experimenting with sculpture. As financial constraints prevented him from working in bronze, he saw what he could do with acrylic resin and sawdust. However few of these early sculptures have been preserved, and like the early paintings, they are now difficult to find. The photograph of a small head dating from 1964, a so-called *Bishop*, shows an example of these exploratory essays in sculpture. Botero painted the synthetic material very realistically, and hence this bishop is reminiscent of the wooden sculptures of the colonial period, such as were made in large numbers and astoundingly high quality in particular in 18th-century Mexico. In the long term Botero was not satisfied with the material, because it was too porous, not durable, and its earthy consistency did not match up to his expectations.

It was not until 1973, when he moved to Paris and was financially more secure, that Botero turned to sculpture once again. In 1976 and 1977 he did almost nothing else. In the early 1980s he acquired two houses in Pietrasanta, one of which serves as a workshop, the other as a home. From here he has a view of Europe's most famous marble quarries, from which Michelangelo hewed his blocks, and many subsequent artists too. In the meantime many of the best foundries have also opened up for business here, and this is the main reason why Botero prefers the place. Bronze is his favorite material for sculptures. It was here in Italy that his sculptural output, now numbering more than 200 works, was created. By no means is this just a sideline to his painting, but rather the natural extension of the latter where the essence of his artistic ideas is concerned: namely the sensuous quality of the forms, technical perfection, classical themes. The aesthetic and formal guidelines of his painting and their figuratively South American character also find their expression, in other words, in Botero's sculptures. They too emphasize the voluminous, extended contour in the sense of a three-dimensional this-worldliness and a physical presence.

This sculptural œuvre is inspired by a number of very different sources, including early Egyptian art with its calm, heavy, semiabstract and supple forms as well as the anthropomorphic vessels and stone sculptures of early American cultures. They also emanate something of the cultic. The colossal female nudes for example are reminiscent of prehistoric fertility idols, his monumental animals of sphinxes or of the figures guarding the entrances to the temples of the ancient world. Because the narrative element is missing, these sculptures invoke to a

Small Head (Bishop), ca. 1963
Acrylic mass mixed with sawdust, 18.5 x 15 cm
Private collection

OPPOSITE:
Large Torso, 1983
Bronze, 332 x 162 x 121 cm
Private collection

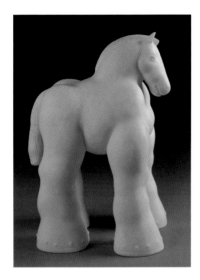

Horse, ca. 1984
Painted bronze, 50 x 23 cm
Private collection

OPPOSITE:
The Lovers (smal version), 1982–83
Painted bronze, 92 x 55 x 56 cm
Private collection

greater degree that sublime, altogether mythical timelessness that Botero so admires in the works of art of any culture. The themes and titles of these works have been chosen accordingly: *Adam and Eve, Motherhood, Horseman, Leda and the Swan, Europa on the Bull.*

Perfect craftsmanship is no less important for Botero's sculptural œuvre than for his painting. In the Versiliese, Tesconi, Mariani and Tomassi foundries he has discovered the skilled workers who are so vital to the manufacturing of the sculptures. Henry Moore, who likewise demanded an immaculately smooth surface to his bronzes, a surface that invited stroking, also had his works cast here.

Work begins however in the studio, where Botero transforms his pictorial ideas into clay. This stage of working with clay is analogous to the drawing stage of a painting: it marks what is actually the creative act in the production of the work. Botero then has a plaster-of-paris model made in the required size, from which either the casts are made, or which serves as a model for a one-off marble.

Botero's sculptures can attain gigantic dimensions. Alongside a normal size for "domestic use," he has created a number of monumental works. In spite of their weight, these works of truly Olympian size have been on an impressive world tour. Displayed for the first time in Forte Belvedere in Florence in 1991, they went the next year to Monte Carlo, before captivating the Parisian public on the Champs-Elysées. After that, they were exhibited on Park Avenue in New York in 1993, where they reconciled many a stern critic with the artist. This display ran in parallel with the major exhibition of modern Latin American art at New York's Museum of Modern Art, which also sharpened minds for a more serious critical examination of his work. It is quite possible that Botero's sculptures provide easier access to his artistic world than do his paintings, which are often admired while at the same time their figurative character is often thought of as exaggerated. The perfect, immaculate and shining casts are also astounding in their fine patination and the professional craftsmanship of their execution. But the monochrome bronzes make a less confusing impression when placed in real space. Botero's conservative, seemingly academic assertion is here not perceived as such, because the formal aspect seems more austere and comes to the fore. For this reason the exaggeration and unreality are seen more unambiguously as purely stylistic elements. The anecdotal gives way to a greater spirituality, and hence the "fat people" here are much more sculptural in form than human figures.

Botero's monumental sculptures were erected in Madrid in 1994, in Israel in 1996, in Santiago de Chile and Buenos Aires in 1997, and in Lisbon in 1998. For the artist, though, the exhibition in the Piazza della Signoria in Florence in 1999, where his works took their place beside those of Michelangelo, Cellini and Giambologna, must have seemed like a dream come true. There stood not only *Adam and Eve,* the famous *Hand of the Artist* and the *Maternité,* but also one of his American ladies in a floral dress with her male counterpart in business suit, hat and tie. Hardly any other artist of the 20th century has ever been honored in this way. Homage to the young Colombian who had embarked on his artistic career here 40 years earlier?

"My sculptures have no particular message –
neither a social message, nor any other. I do
not think that art can change the political
situation. My sculptures have no symbolic
significance of any kind. What I am interested
in is form – gentle, round surfaces, which
emphasize the sensuousness of my work."
FERNANDO BOTERO

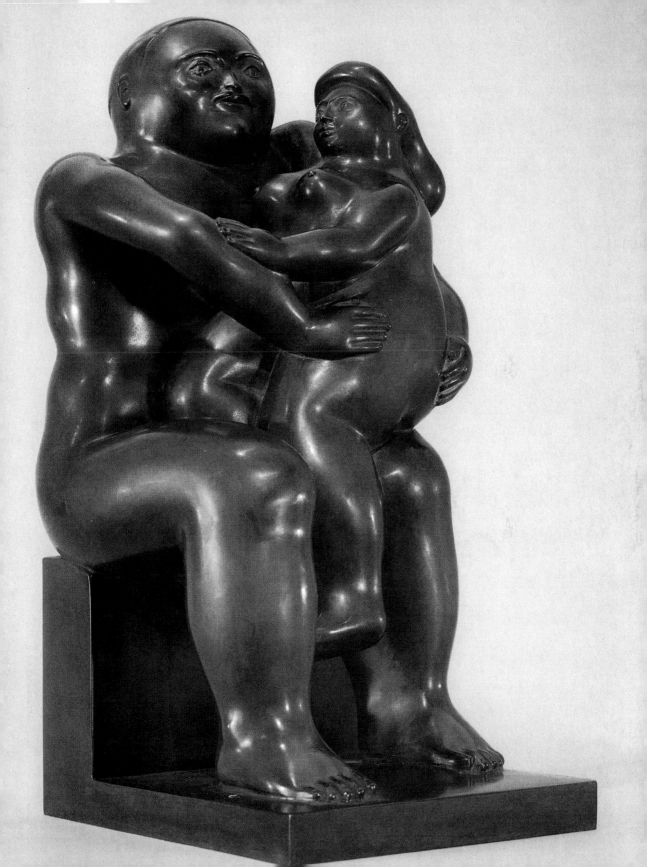

Biography

1932 Fernando Botero is born in Medellín on 19 April 1932, the second of three children, to David Botero and his wife Flora Angulo. Medellín is an industrial and commercial city situated high in the Colombian Andes. The father is a sales representative, travelling the barely accessible surrounding region on horseback.

1936 Fernando's father dies.

1938–1949 Fernando attends primary school, then wins a scholarship to attend the Jesuit high school in Medellín. At the age of 12 he enrolls at the bull-fighting school. His first watercolors depict bull-fighting scenes as well as landscapes. While still at school, he draws illustrations for the *El Colombiano* newspaper.

1949–1950 Botero continues his schooling at the Liceo San José in neighboring Marinilla and pays for it by drawing illustrations for newspapers.

1950 Final examinations, followed by two months as a stage-set designer for the Spanish theater troupe "Lope de Vega."

1951 At the age of 19, Botero moves to the capital, Bogotá, where he meets the Colombian avant-garde centering on the writer Jorge Zalamea, a close friend of Federico García Lorca. Five months after his arrival in Bogotá, Botero has his first exhibition of 25 watercolors, gouaches, drawings and oil paintings at the Leo Matiz Gallery. He sells a few paintings and spends the summer painting at Tolú, on Colombia's Caribbean coast.

1952 The previous summer's pictures are displayed at a second exhibition at the Leo Matiz Gallery, in May. All the pictures are sold, for a total of some 2,000 US dollars. In August he is awarded the Second Prize at the Ninth Salon of Colombian Artists for his paintings, worth 7,000 pesos. Now at last he can go to Europe, and sails to Barcelona in August with artist friends. After a few days in the city of Picasso, he proceeds to Madrid, where he enrolls in the Academia San Fernando, Madrid's academy of art. He spends most of his time in the Prado, where he studies the Old Masters: Velázquez, Titian, Rubens, Goya. He produces copies to earn a little more money.

1953 Stays in Paris with his friend the film director Ricardo Irragarri. Botero is disappointed at the art he sees in the Musée d'Art Moderne and spends most of his time in the Louvre.

1953–1954 In August 1953 Botero and Irragarri travel to Florence. Botero enrolls in the Accademia San Marco to study the art of fresco painting, and moves into the studio once used by the painter Fattori in the Via Panicale, where he paints in oils. He attends lectures by the art historian Roberto Longhi and reads Bernard Berenson's essays.

1955 Returns to Bogotá in March. In

May exhibits the pictures he has brought back from Florence at the National Library. They are not well received, and no pictures are sold. Botero earns his living drawing for magazines. In December he marries Gloria Zea.

1956 At the start of the year, the Boteros move to Mexico City. Fernando is invited to take part in a group exhibition at the Museum of Fine Art in Houston, for which he paints a *Still Life with Mandolin* in which the later so characteristic voluminous motifs appear for the first time.

1957 Botero goes to Washington DC for his first solo exhibition in the United States, held in April under the auspices of the Pan-American Union. The exhibition is very successful, all the works are sold. He meets Tania Gres, who has opened a gallery in Washington. In May Botero returns to Bogotá. He takes part in the Tenth Colombian Salon, where he wins the Second Prize once more, this time with his painting *Sleeping Bishop*.

1958 Appointed professor of painting at the Bogotá Academy of Art. His daughter Lina is born. The daily newspaper *El Tiempo* publishes Gabriel García Márquez' story "La siesta del martes" with illustrations by Botero. At the Eleventh Colombian Salon Botero enters his monumental paint-

ing *Camera degli sposi* after Mantegna's famous frescoes in Mantua: at first it is rejected, but then, after vehement protests and much newspaper coverage, is finally awarded First Prize. First solo exhibition at the Gres Gallery in Washington: a great success, all the pictures are sold. On the occasion of the Guggenheim International Award, Botero exhibits at the New York Guggenheim Museum.

1959 Together with Enrique Grau, Alejandro Obregón and Eduardo Ramirez Villamizar, Botero represents Colombia at the Fifth São Paolo Biennale, and attracts attention with his painting *Mona Lisa at the Age of 12*.

1960 Execution of large fresco for Banco Central Hipotecario in Medellín. Botero's son Juan Carlos is born in Bogotá. A second exhibition at the Gres Gallery in Washington. Botero moves to New York. He rents a student room on the corner of MacDougall and Third Streets in Greenwich Village. The Gres Gallery in Washington closes. In November he wins a prize under the terms of the Guggenheim International Award for his painting *The Battle of the Arch-Devil*. His marriage to Gloria Zea is dissolved.

1961 Exhibition at the El Callejan Gallery in Bogotá. A curator of the Museum of Modern Art, Dorothy C. Miller, visits Botero at his studio and on her initiative the museum, which is headed by Alfred H. Barr, acquires the first version of *Mona Lisa at the Age of 12*.

1962 In Botero holds his first exhibition in New York, at the gallery The Contemporaries.

1963 While the Metropolitan Museum is displaying Leonardo da Vinci's *Mona Lisa*, the Museum of Modern Art displays Botero's *Mona Lisa at the Age of 12*. Botero moves his studio to the Lower East Side.

1964 Marries Cecilia Zambrano. In Bogotá Botero wins the First Prize at the "Salón Intercol de artistas jóvenes,"

held by the Museum of Modern Art for a *Still Life with Apples*.

1966 Botero goes to Europe to open his exhibition at the Kunsthalle in Baden-Baden, which later moves to the Galerie Buchholz in Munich. September sees the first exhibition at the Galerie Brusberg in Hanover. In December, for the first time, a museum exhibition is devoted to him in the United States.

1967 Botero lives in Colombia and New York, traveling to Germany and Italy.

1969 In March, paintings and large charcoal drawings are exhibited at the Center for Inter-American Relations in New York. September sees his first exhibition in France, at the Claude Bernard Gallery.

1970 Birth of his son Pedro. March sees the start of a major touring exhibition of 80 paintings in Germany, opening at the Kunsthalle in Baden-Baden, and proceeding to the Haus am Waldsee in Berlin, the Kunstverein Düsseldorf, the Hamburger Kunstverein and the Kunsthalle in Bielefeld.

1971 Botero rents a flat in Paris and spends his time between Paris, Bogotá and New York, where he now has a studio on Fifth Avenue.

1972 In February Botero's first exhibition at the Marlborough Gallery in New York is held. He now sets up a

studio in Paris, in the rue Monsieur-le-Prince. He buys a summer house in Cajica, north of Bogotá.

1973 Moves to Paris. Starts making sculptures.

1974 The first retrospective opens in Bogotá. His four-year-old son Pedro dies in a road accident in Spain, where the family is on holiday.

1975 His second marriage, to Cecilia Zambrano, is dissolved.

1976 Major retrospective at the Museum of Contemporary Art in Caracas. Botero is awarded the Venezuelan Order of Andrés Bello. An exhibition of watercolors and drawings is held at the Claude Bernard Gallery in Paris.

1977 In memory of his dead son, Pedro, Botero donates 16 works to the Museo de Zea in Medellín.

1978 Botero transfers his Paris studio to the rue du Dragon, where the former Académie Julian was situated.

1979 Major touring exhibition in Belgium, Norway and Sweden. Cynthia Jaffee McCabe organizes the first retrospective in the United States at the Hirshhorn Museum in Washington.

1980 First exhibition at the Galerie Beyeler in Basel with watercolors,

drawings and sculptures. Botero publishes his first short stories in the newspaper *El Tiempo*.

1981 Retrospectives in Tokyo and Osaka.

1983 The Metropolitan Museum buys the painting *Dance* in Colombia. Botero sets up a studio in Pietrasanta in Italy. The place is famous for its marble quarries and its foundries. From now on, Botero produces his sculptures nowhere else.

1986 Exhibitions of drawings in the Museo de Arte Contemporáneo in Caracas. Retrospectives in Munich, Bremen and Frankfurt, as well as in Tokyo once more and three other Japanese cities.

1987–1988 In December an exhibition is held at the Castello Sforzesco in Milan with 86 oil paintings, watercolors and drawings on the theme of the bull fight. The following year this exhibition moves to Naples and to Knokke on the Belgian coast.

1990 Retrospective with oil paintings, drawings and sculptures at the Fondation Pierre Gianadda in Martigny, Switzerland.

1991–1992 Botero's monumental sculptures are shown in the Castello Belvedere in Florence, in 1992 in the Casino in Monte Carlo and along the Champs-Elysées in Paris.

1993 For the first time in the history of New York, sculptures are displayed along Park Avenue; 16 monumental bronzes by Botero dating from the previous few years.

1994 Botero's monumental sculptures are set up in Madrid's prestigious boulevard, the Castellana. Botero narrowly escapes being kidnapped in Bogotá.

1995 In Medellín a bomb explodes near a Botero sculpture; 27 people are killed and many injured. Botero donates further works to his native city.

1996 Further exhibitions of the sculptures in public squares and parks, among other places in Jerusalem and Santiago de Chile.

1998 A major retrospective of Latin American art is held in Montevideo, Monterey and Mexico.

1999 Thirty monumental sculptures are exhibited in the Piazza della Signoria in Florence. Botero is the first artist to have his sculptures displayed alongside those of Cellini, Giambologna and Michelangelo.

2000 Botero donates 100 masterpieces from his collection to Bogotá, including pictures by Corot, Monet, Pissarro, Renoir, Degas, Toulouse-Lautrec, Matisse, Chagall, Miró, Klimt, Picasso, Dalí, Beckmann, Matta, Rauschenberg, Schnabel and Stella. An old colonial building is restored to house them. In addition, he donates more than 200 of his own works to his native city of Medellín.

2001–2002 Mexico City stages a major exhibition on Botero's life as an artist, with the title "50 anos de Vida Artística." At the same time a major retrospective starts in Scandinavia, moving

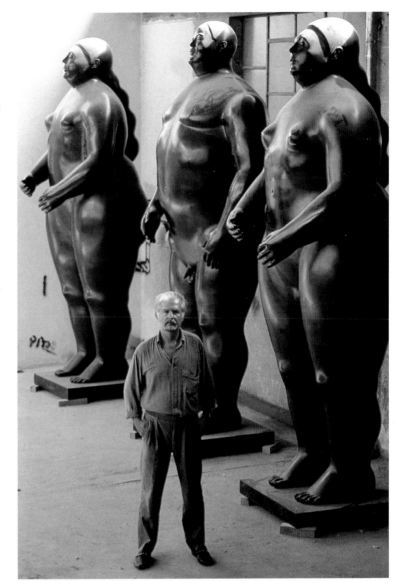

from the Moderna Museet in Stockholm to Copenhagen. Botero lives in Paris, New York, Monte Carlo and Pietrasanta. Because of the terrorist threat, he visits to Colombia only for a few hours at a time, for example to open the museums in Bogotá and Medellín.

Bibliography

Arciniegas, Germán: *Fernando Botero,* Madrid 1973 / New York 1977.

Bode, Ursula: *Fernando Botero: Das Plastische Werk,* Hanover 1978 (Galerie Brusberg edition).

Engel, Walter: *Botero,* Bogotá 1952.

Escallón, Ana Maria: *Fernando Botero, un utópico realista,* Bogotá 2000.

Gallwitz, Klaus: *Botero,* Munich 1970 (Galerie Buchholz edition).

Gallwitz, Klaus: *Fernando Botero,* Stuttgart, New York, London 1976.

Gibaudo, Paola: *Botero: Affreschi Chiesa della Misericordia,* Turin 1993.

Jouvet, Jean: *Botero,* Paris 1985.

Paquet, Marcel: *Botero, philosophie de la création,* Brussels 1983.

Ratcliff, Carter: *Botero,* New York 1980.

Rivero, Mario: *Botero,* Barcelona 1973.

Spies, Werner: *Fernando Botero,* Munich 1986.

Sullivan, Edward: *Fernando Botero: Drawings and Watercolors,* New York 1993.

Sullivan, Edward: *Botero: A Monograph and a Catalogue Raisonné, Paintings 1975–1990,* Lausanne 2000.

Vargas Llosa, Mario: *Botero,* New York 1985.

Photocredits